NEW ENGLAND
REDISCOVERED

I would like to say thanks to all my friends and some strangers for their assistance and hospitality, and special thanks to the following: Mystic Seaport Museum, Mystic, Connecticut; Yale University, New Haven, Connecticut; Mohegan Sun, Uncasville, Connecticut; Mashantucket Pequot Tribal Nation, Foxwoods, Connecticut; Greenwich Historical Society, Greenwich, Connecticut; Sakonnet Vineyards, Little Compton, Rhode Island; Newport Historical Society, Newport, Rhode Island; Newport Jazz Festival, Newport, Rhode Island; International Yacht Restoration School, Newport, Rhode Island; *Bill of Rights*, Newport, Rhode Island; Herreshoff Marine Museum, Bristol, Rhode Island; Marblehead School of Ballet, Marblehead, Massachusetts; Boston Red Sox Baseball Club, Boston, Massachusetts; Mass MOCA, North Adams, Massachusetts; Plimoth Plantation, Plymouth, Massachusetts; Scargo Pottery, Dennis, Massachusetts; Fool on the Hill Gift Shop, Quechee, Vermont; University of Vermont Morgan Horse Farm, Weybridge, Vermont; Shelburne Museum, Shelburne, Vermont; Stowe Mountain Ski Area, Stowe, Vermont; Justin Smith Morrill Homestead, Strafford, Vermont; Strawbery Banke, Portsmouth, New Hampshire; Saint-Gaudens National Historic Site, Cornish, New Hampshire; Mahoosuc Guide Service, Newry, Maine; Moir Potato Farm, Caribou, Maine; Chez Lonndorf, Skowhegan, Maine; Wrinkle in Thyme Farm, Sumner, Maine; Capt. John E. Norton Puffin Tour, Jonesport, Maine.

ISBN-13: 978-1-889833-68-2
ISBN-10: 1-889833-68-1

Cover and interior design by Anne Lenihan Rolland
Printed in China

Published by Commonwealth Editions
266 Cabot Street, Beverly, Massachusetts 01915
Visit us on the Web at www.commonwealtheditions.com.

To sample Ulrike Welsch's archive of international photographs, visit www.ulrikewelschphotos.com.

Photo, page 4: Start of Boston Marathon, Hopkinton, Massachusetts

10 9 8 7 6 5 4 3 2 1

NEW ENGLAND
REDISCOVERED

PHOTOGRAPHS BY ULRIKE WELSCH

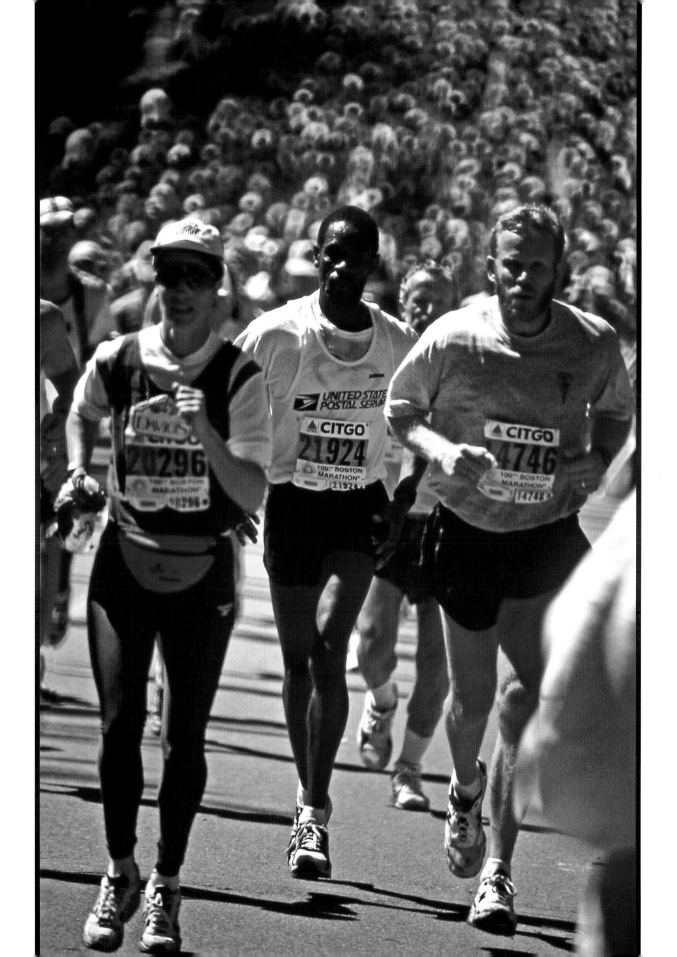

CONTENTS

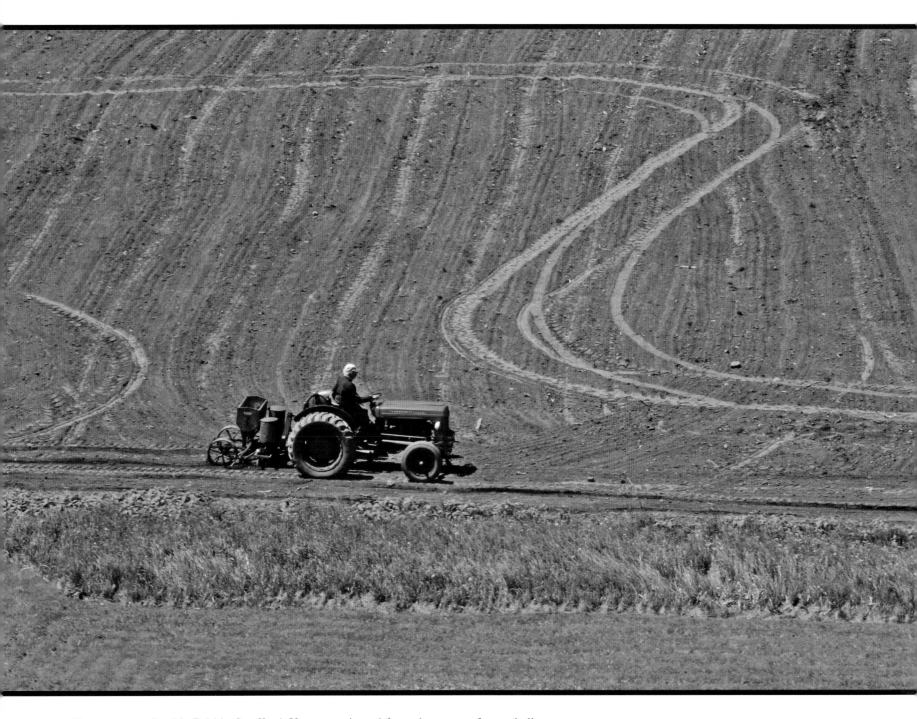

Farmer preparing his field in Strafford, Vermont, viewed from the tower of town hall

FOREWORD

Since I arrived in New England from my native Germany four decades have passed. I have lived longer here than there! Boston has become my new center of the universe. I have settled and remained in New England for several reasons: I love the change of seasons, the closeness to nature, and the culture. And people have always accepted me—both the way I was when I first arrived and the way I have become. Here I have learned what photojournalism is all about, what makes a strong image, an image that speaks.

My beginnings in photography were in black-and-white, and a few selections from those early days are included here. For the last year and a half, after photo safaris the world over, I have roamed New England anew—this time not only in color, but also with my digital camera. Times have changed and with it the medium.

To get better views and angles, I climbed a potato-harvesting machine, scrambled down a cliff at West Quoddy Light, got up for early light, mooed with cows at their trough, was mesmerized by the drums at a powwow, hiked the Presidential Range, taught my dog silence and patience . . . It was fun and always a challenge. I love to rediscover places while finding new ones as I roam. The mood, the light, the welcome—all of this plays a part for me when capturing images.

When my publisher discovered me some seven years ago, I could never have imagined that this would become such a lasting book experience. Here you are opening my fifth publication with Commonwealth Editions—my vision of New England. I tripped those shutters so many times that I could fill a library now. We had to make a tough and tight selection, trying to balance all the meaningful places that help make up New England. But it's not only the places that create a region, it's the people as well—and I appreciate and thank all of you for letting me roam freely.

—*Ulrike Welsch*
Spring 2006

CONNECTICUT

I loved Lyme and Mystic with their beautiful coastlines, and the informative Seaport with its rich maritime history. I saw downtown Hartford and "Mother Yale" in New Haven, not far from where tribal drums and casinos contrast so strongly with city life. Elsewhere, I found quaint villages, the Goodspeed Opera House, and even a castle above the Connecticut River. Here farmers still raise tobacco and a variety of crops in a fruitful valley.

Opposite: Teens at end of summer vacation working on a tobacco farm, Suffield

Below: *Stegosaurus* by Alexander Calder, 1973, with Travelers Insurance building in background, Hartford

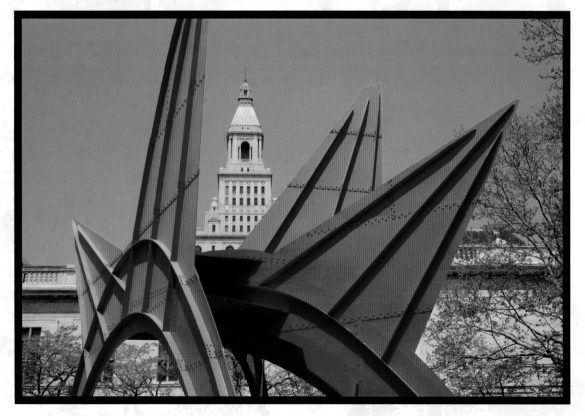

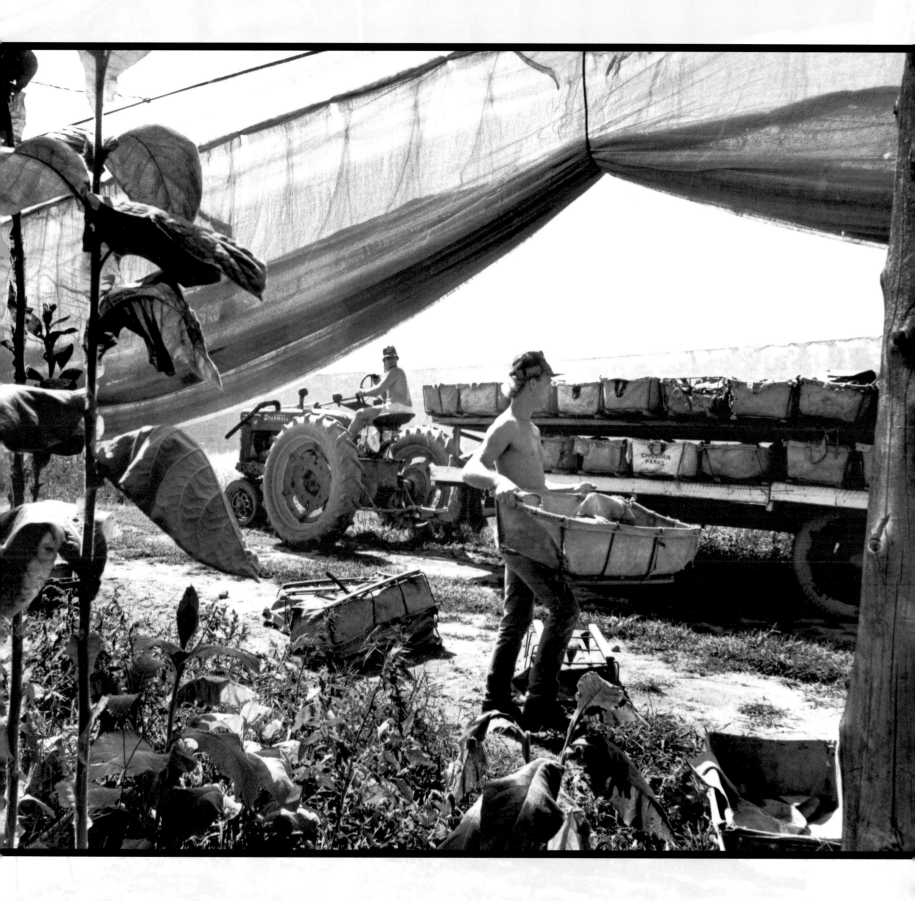

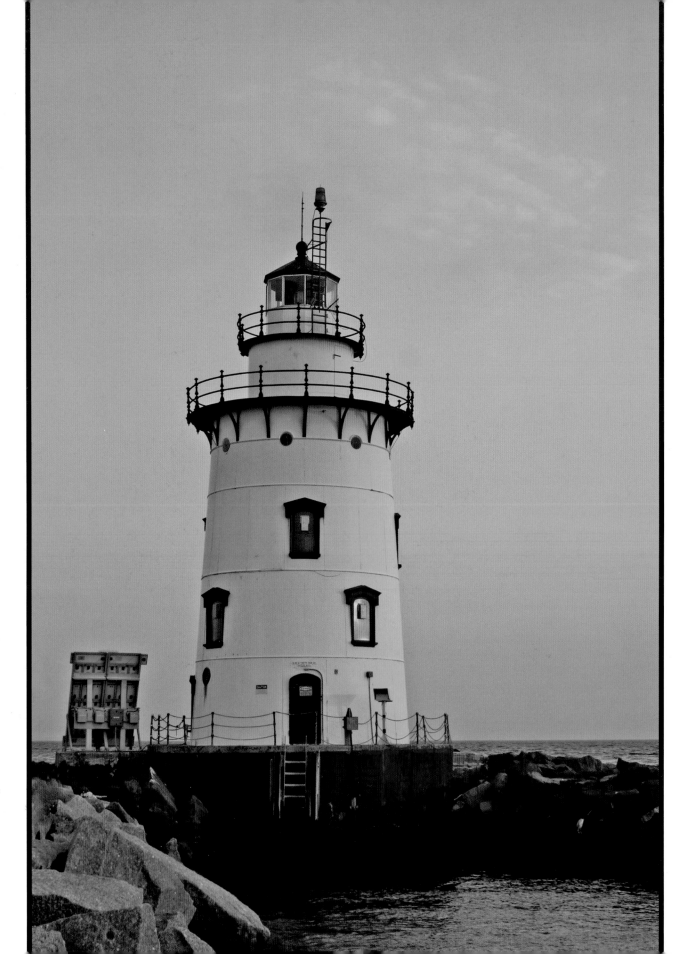

Saybrook
Breakwater Light,
built 1886

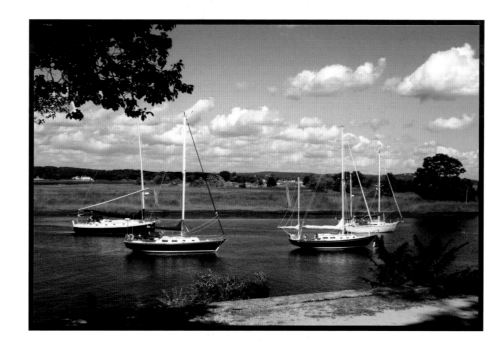

Right: Sailboats in Connecticut River, Old Lyme

Below: *Charles W. Morgan*, built in New Bedford, Massachusetts, 1841, and now the last wooden whaling ship in existence, at Chubb's Wharf, Mystic Seaport

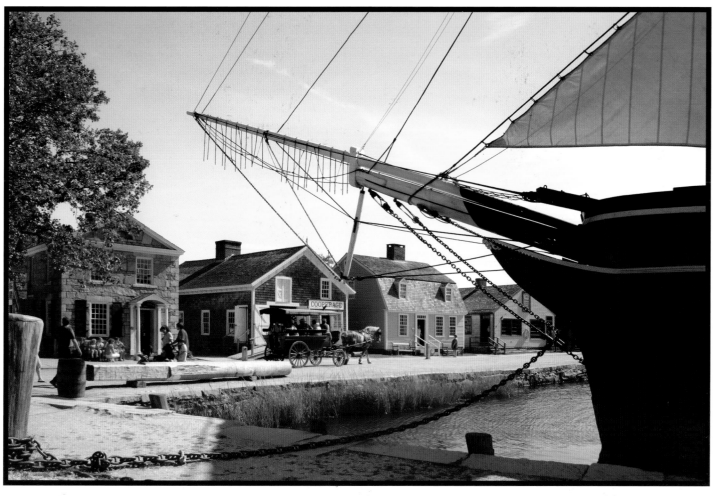

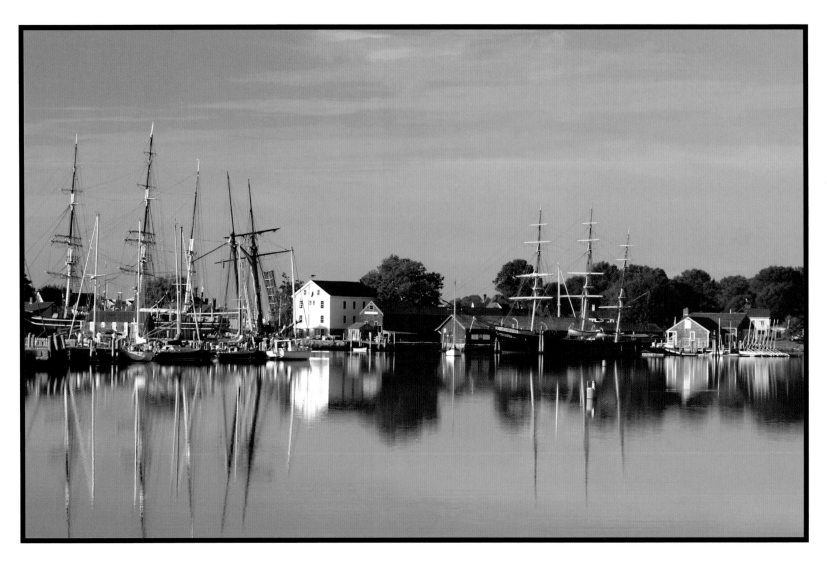

Above: Reflected glory at Mystic Seaport, founded in 1929 to preserve America's maritime history and culture

Right: A carpenter planes wood in a traditional cooperage shop at Mystic Seaport

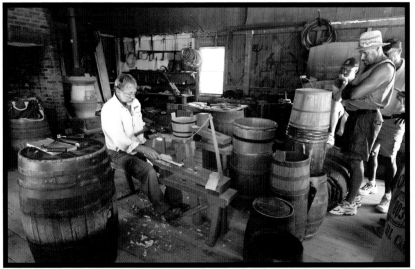

Putnam Cottage, Post Road, Greenwich. Originally built for the Knapp family about 1700, it is named for General Israel Putnam, who used it during the American Revolution.

13

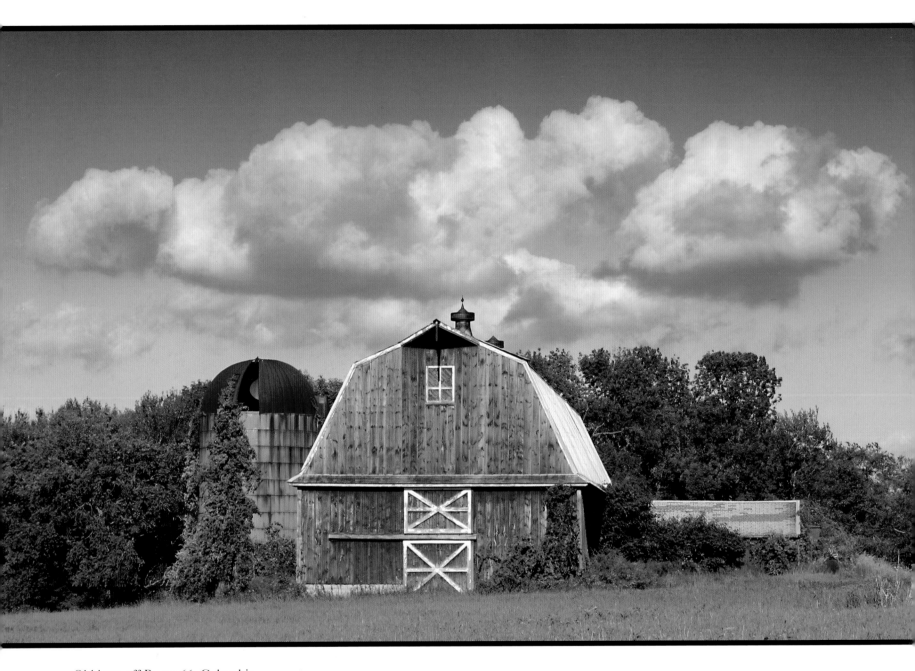

Old barn off Route 66, Columbia

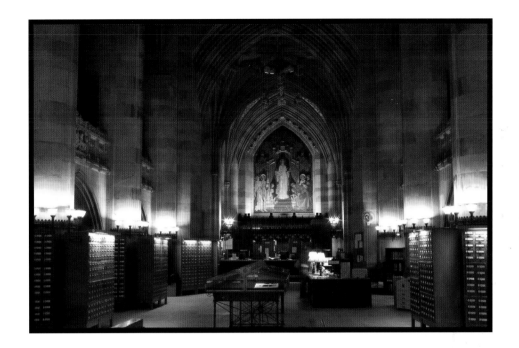

Right: Interior of Sterling Memorial Library, Yale University, New Haven. Above the circulation desk is the allegorical mural *Mother Yale* by Eugene F. Savage (Yale '24).

Below: Cows feeding, Lyme

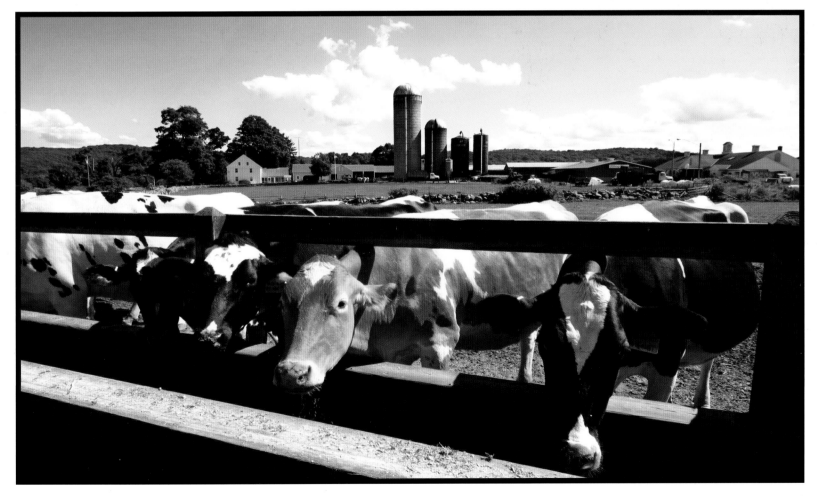

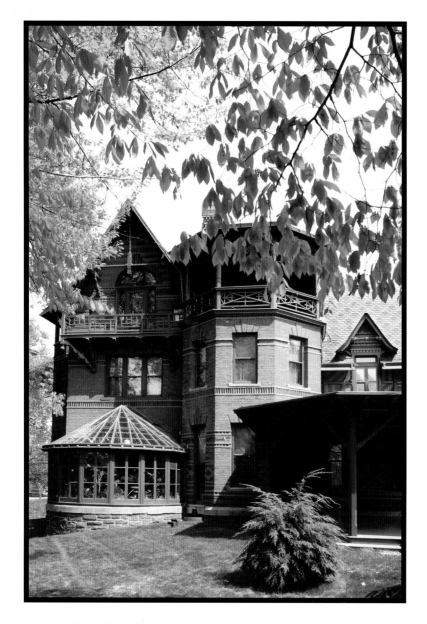

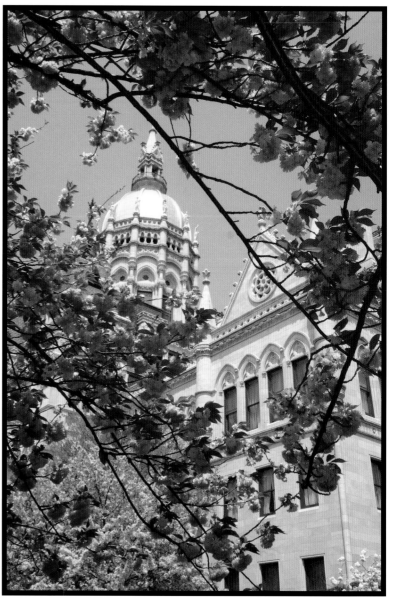

Above: Mark Twain House, Hartford, the nineteen-room, Tiffany-decorated home where Twain lived and worked from 1874 to 1891

Right: Connecticut State Capitol, Hartford, completed in 1879

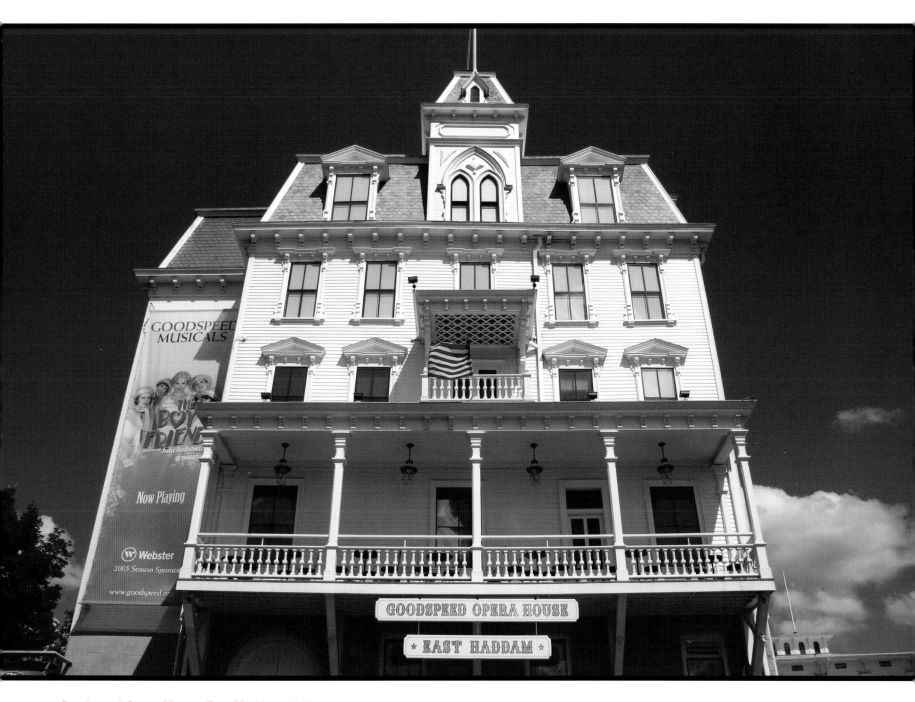

Goodspeed Opera House, East Haddam, built
in 1876 and rededicated to musical theater by
Goodspeed Musicals since 1959

Tokeneke district, Darien

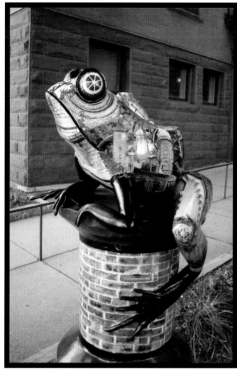

Above: Papier maché frog sitting on a spool of thread outside town hall, Willimantic. The statue commemorates a legendary bullfrog battle on the Willimantic River in 1754, together with Willimantic's historic role in the thread industry.

Left: Skiff, Old Lyme

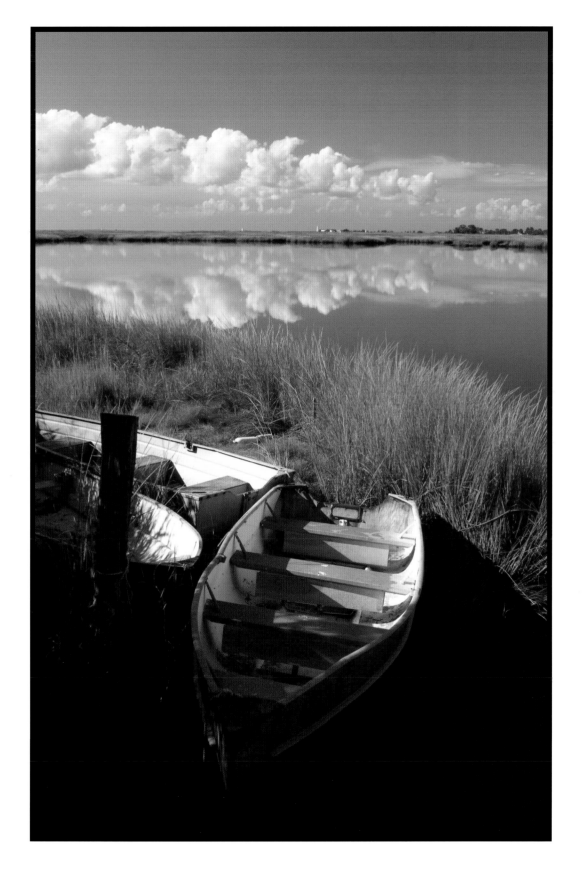

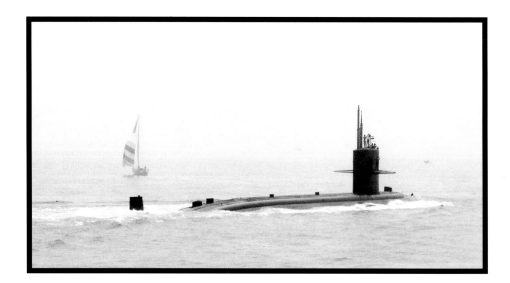

Right: Submarine leaving port, Groton

Below: View from Indian Harbor Yacht Club, Greenwich

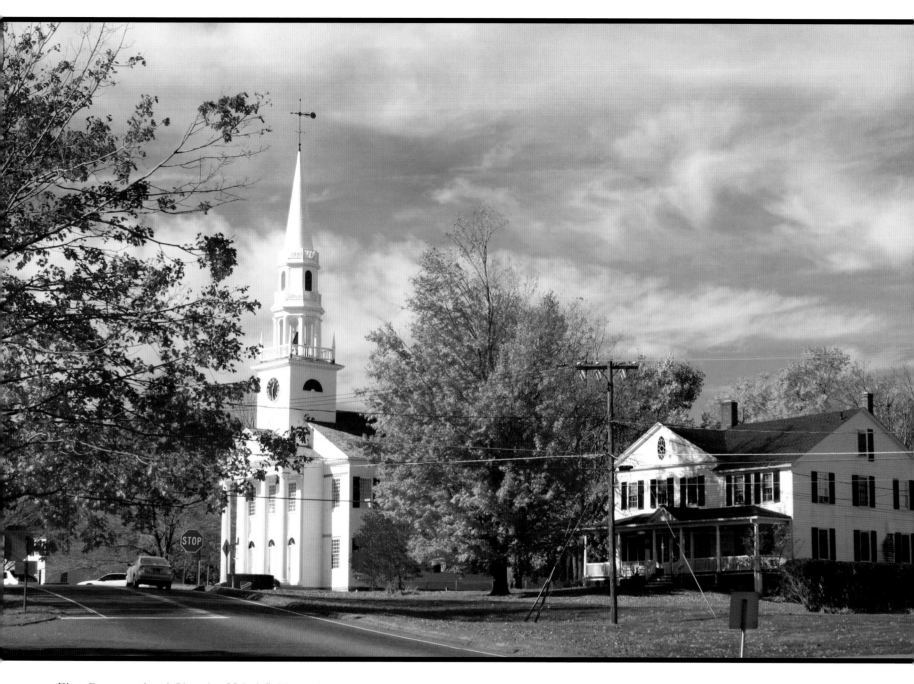

First Congregational Church of Litchfield, on the town green

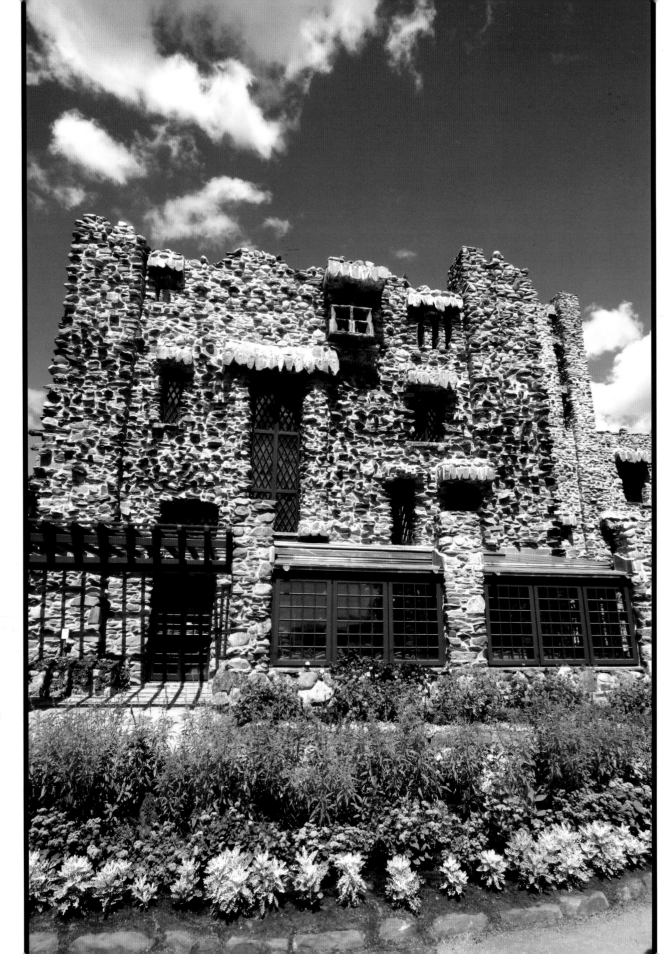

Gillette Castle, East Haddam, built by actor, director, and playwright William Hooker Gillette between 1914 and 1919, and now the centerpiece of Gillette Castle State Park

22

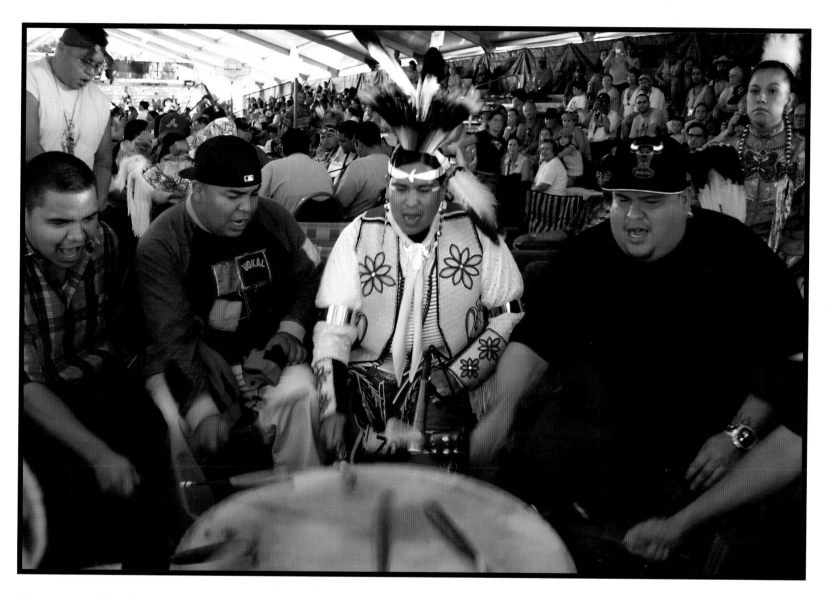

Drummers at Schemitzun, hosted by the Mashantucket Pequot
Tribal Nation. This annual Feast of Green Corn and Dance, on
the Mashantucket reservation near Foxwoods Casino, is one of
the largest intertribal powwows in the nation.

RHODE ISLAND

Providence with its Water Fire radiates spirit and community. Newport offers yachts and mansions, while Little Compton has a quiet beauty of its own, with vineyards where I want to bike in the future. Block Island has its bluffs and well-loved beaches. New England's smallest state is a big surprise—and pleasure—to explore.

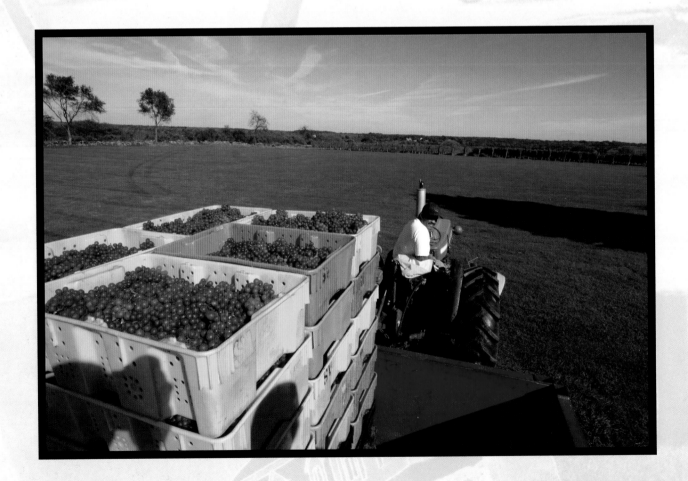

Right: Grape harvest at Sakonnet Vineyards, Little Compton

Far right: Artist, Block Island

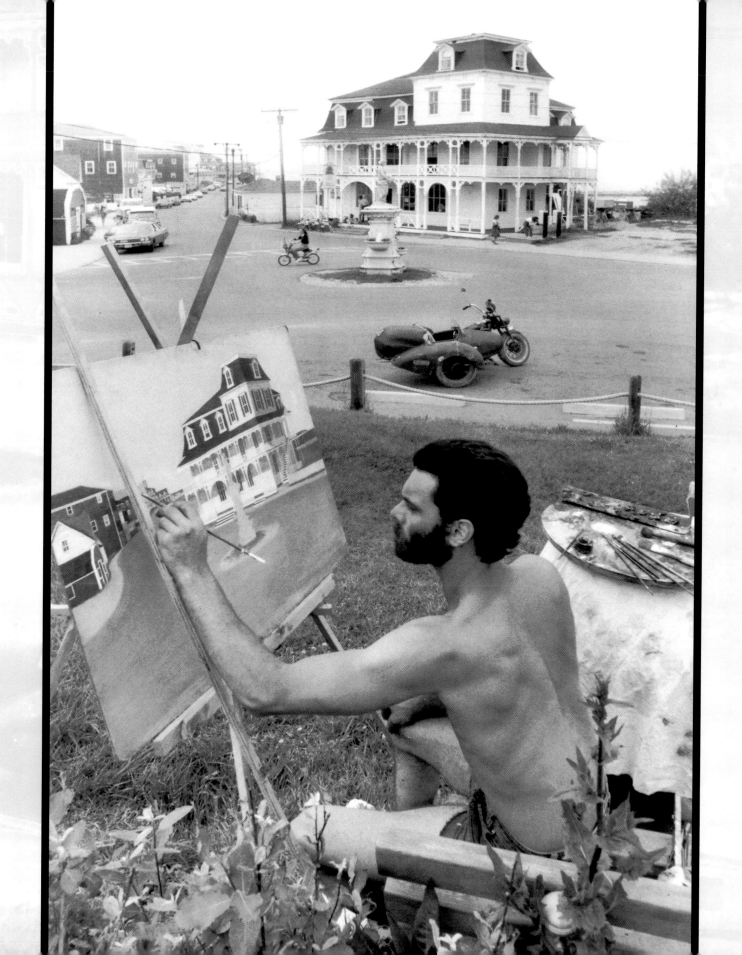

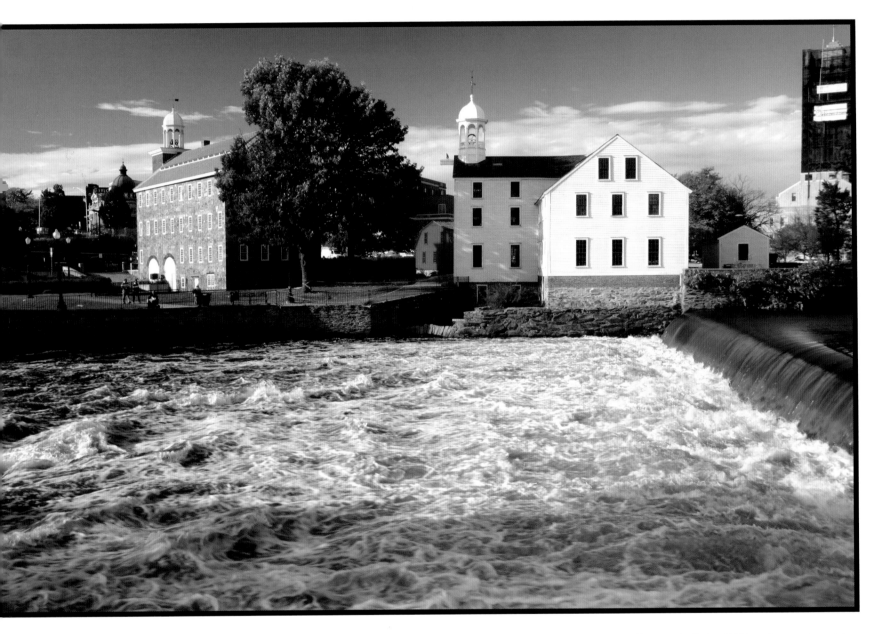

The Slater Mill Historic Site, Pawtucket, includes the Wilkinson Mill, built in 1810; the Sylvus Brown House, built in 1758 and moved to this site in the 1960s; and Slater Mill, the "birthplace of American industry," built in 1793. The Wilkinson Mill contains a reconstructed 16,000-pound water wheel from about 1826, which still powers machines here.

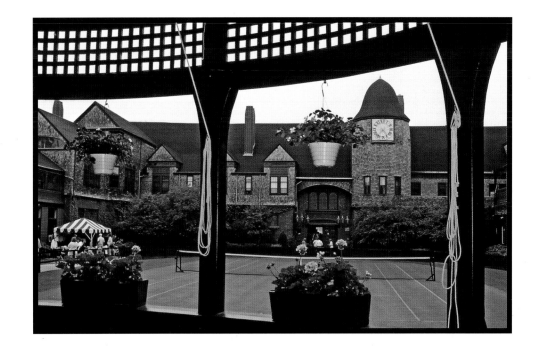

Right: Grass court at the International Tennis Hall of Fame, Newport

Below: *Waterfire*, Barnaby Evans's fire-sculpture installation on the three rivers of downtown Providence

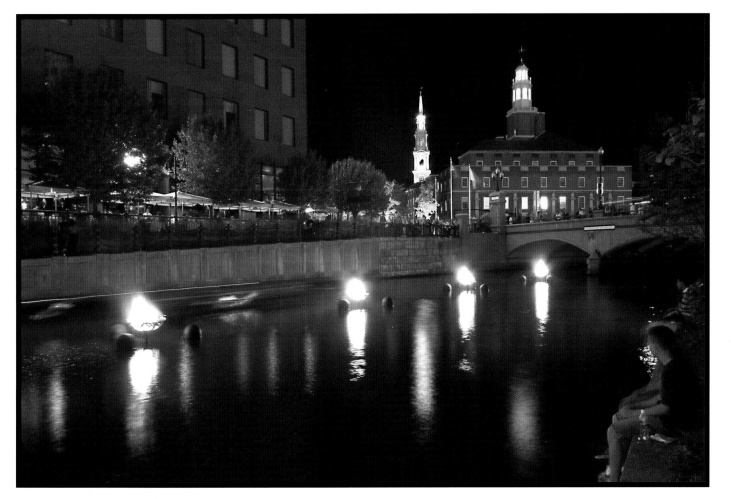

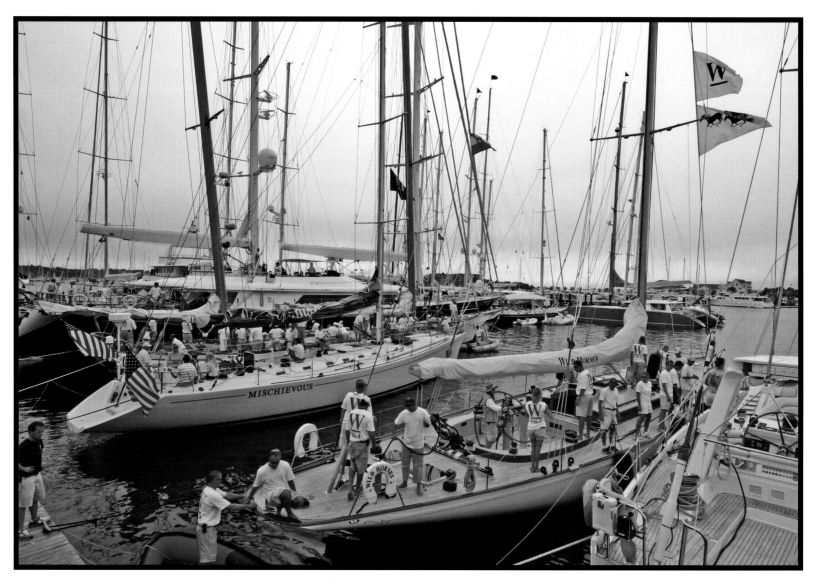

The Newport Bucket, an annual two-day
regatta for yachts of at least 80 feet

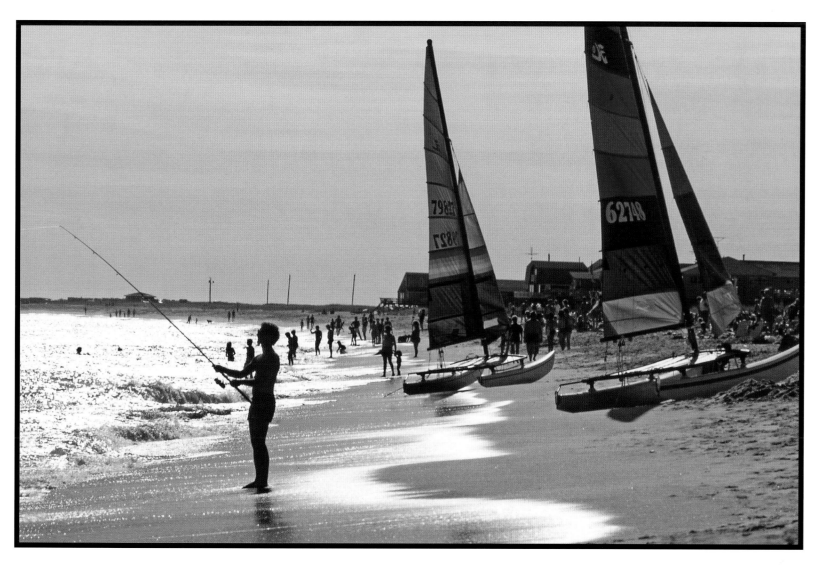

Beach, Charlestown

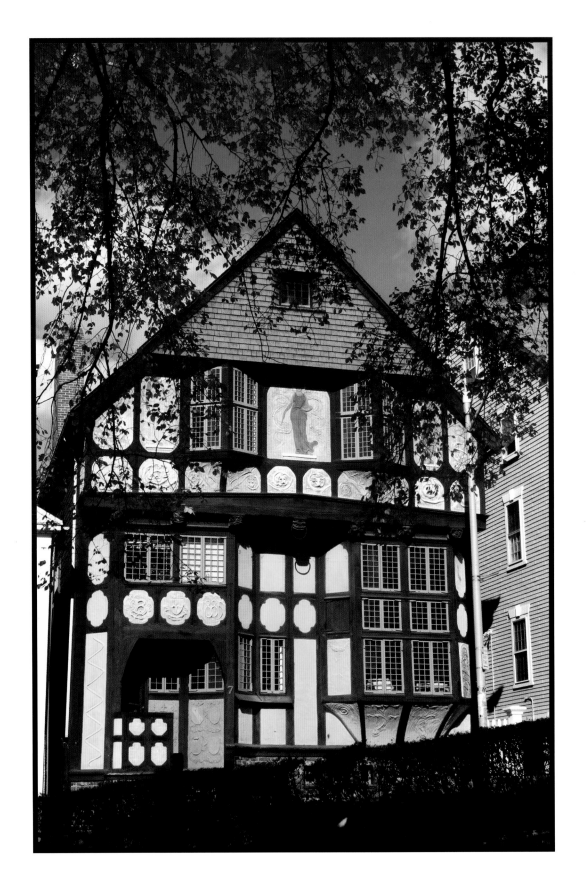

The Fleur-de-Lys building at
7 Thomas Street, Providence,
built in 1885 by artist Sydney
Richmond Burleigh and now
part of the Providence Art Club

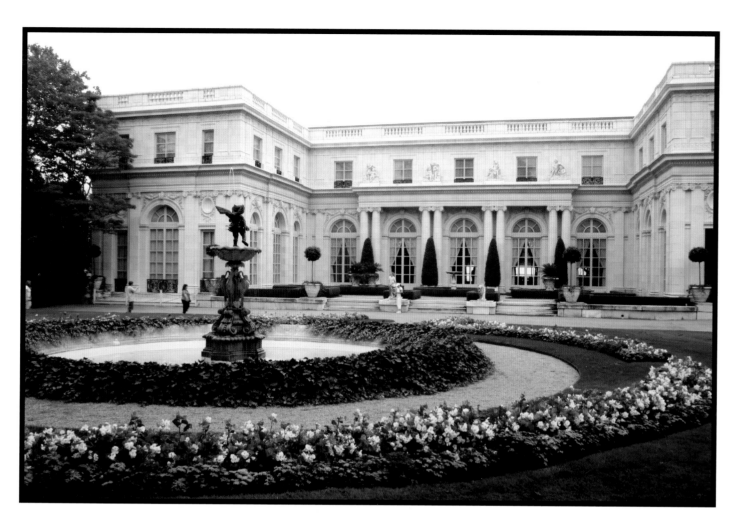

Above: Rosecliff, the Newport mansion
commissioned by Theresa Fair Oelrichs
in 1899 and designed by Stanford White

Right: Gondola, Providence

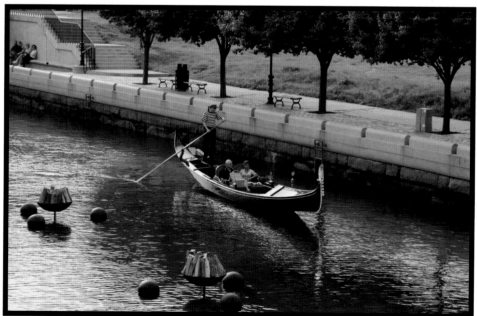

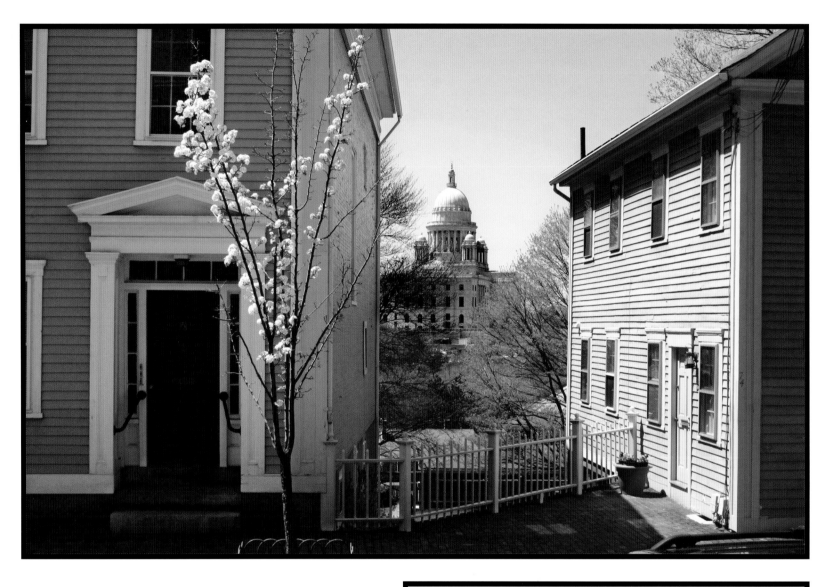

Above: View of Rhode Island State Capitol from Benefit Street

Right: Band members of Wynton Marsalis Quintet, Newport Jazz Festival, 2005

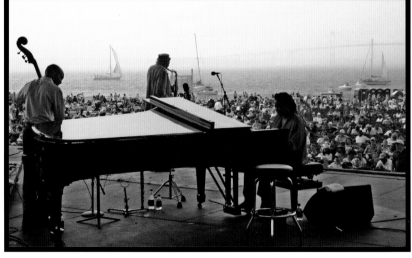

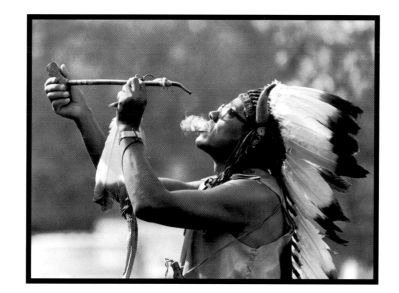

Right: Native American medicine man
leading celebration of Thanksgiving,
Charlestown

Below: Clambake, Bristol

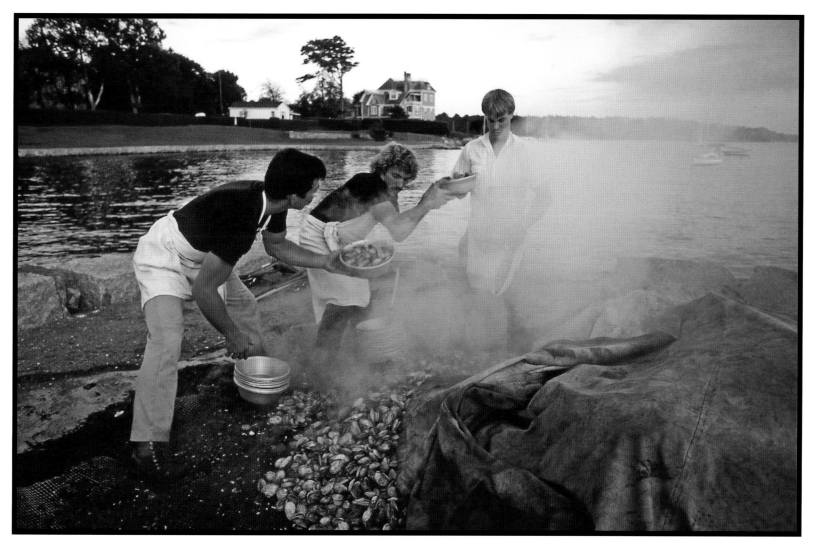

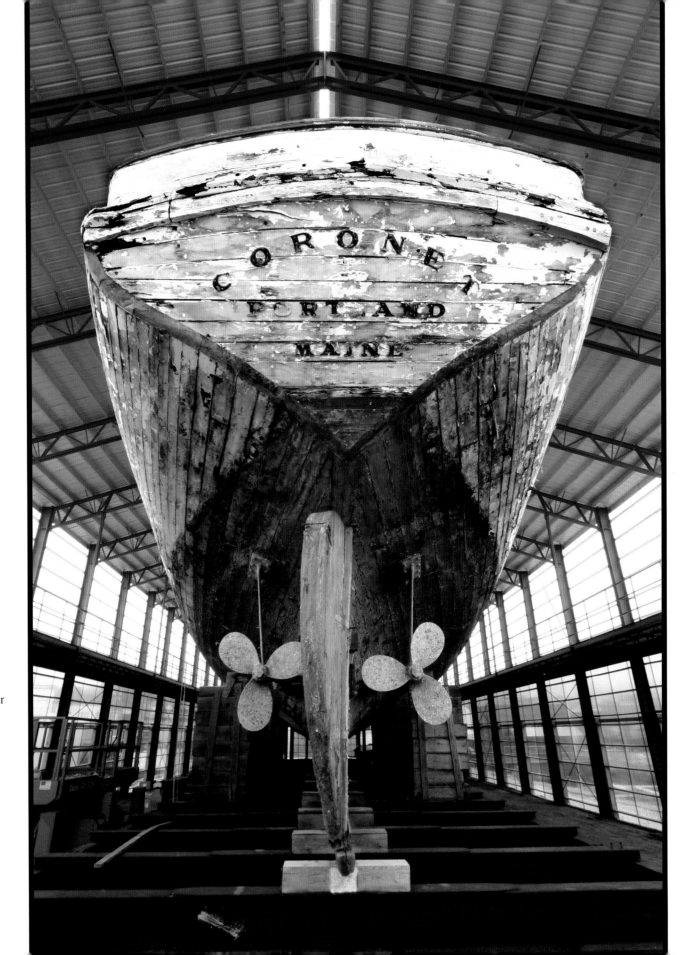

The 133-foot schooner *Coronet*, a grand yacht from the Victorian Era, is being restored by the International Yacht Restoration School in Newport, using original materials and techniques.

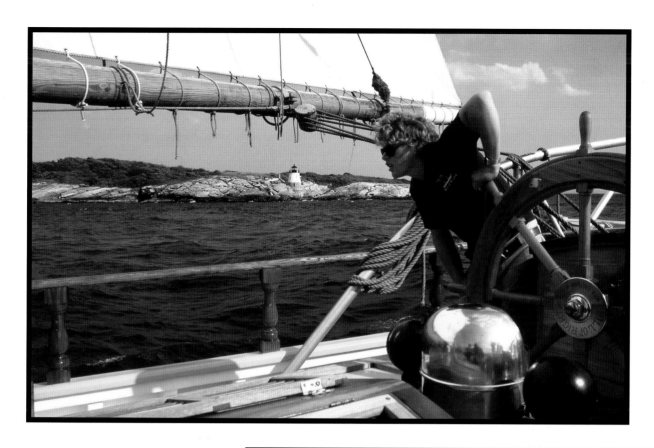

Above: The two-masted schooner *Bill of Rights* steers past Castle Hill Light off Newport

Right: The sloop *Neith*, designed by L. Francis Herreshoff, sails off Bristol

Left: Summer porch, Watch Hill
Below: Beach walk, Block Island

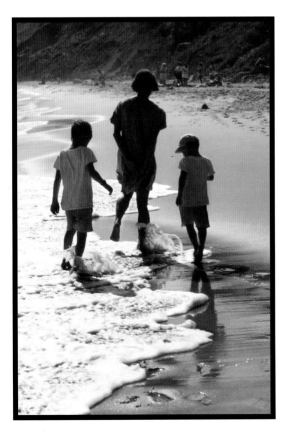

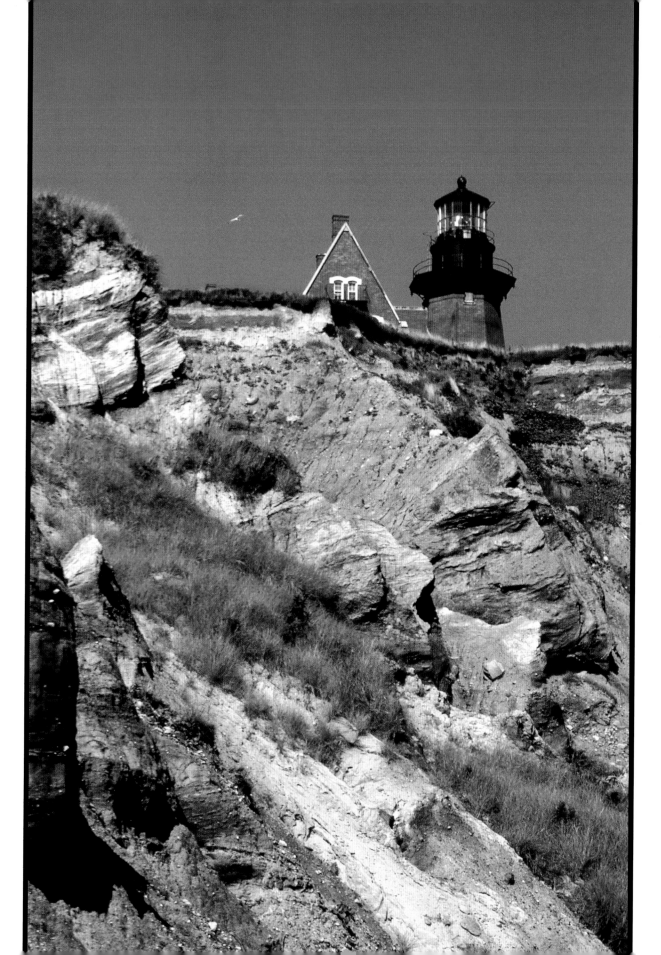

Block Island Southeast
Light, built in 1875

MASSACHUSETTS

My adopted home state seems to encompass so much of everything! There are the islands, Nantucket and Martha's Vineyard, and the Berkshire Mountains. I experienced Cape Cod in winter, with its serenity, and in summer, when it overwhelms with scent and color. I stood in waders in a sea of cranberries and trooped along Revolutionary trails, past the cultural sites of greater Boston.

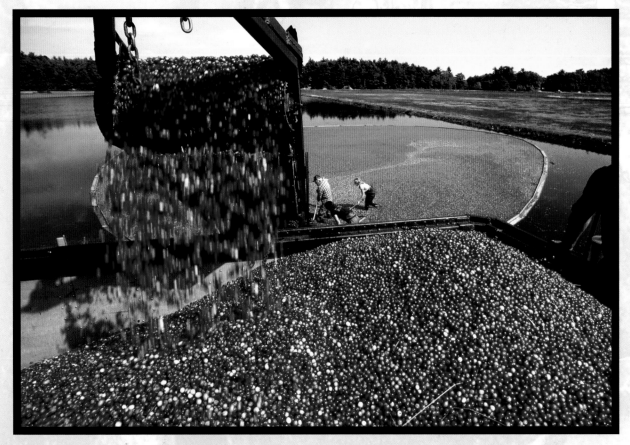

Left: Cranberry harvest, Wareham. Berries are harvested by workers wading in the bog and moved to the truck on a conveyor.

Right: Students from Marblehead School of Ballet at Abbot Hall, Marblehead, studying *Spirit of '76* by Archibald McNeal Willard

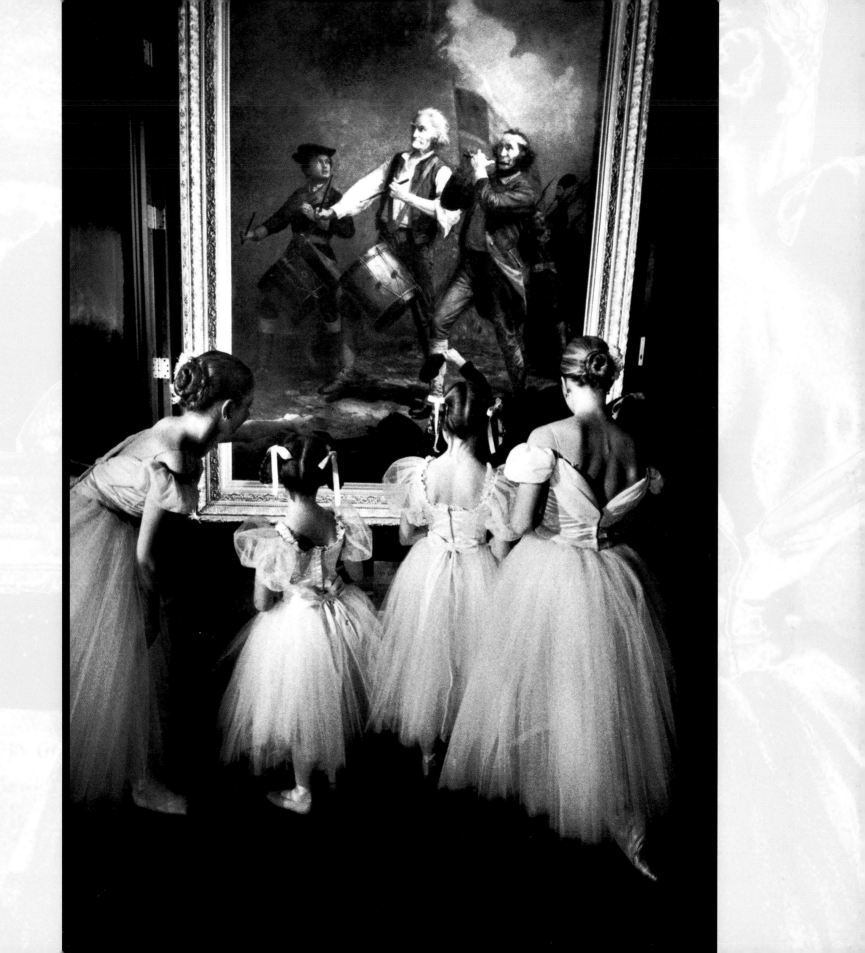

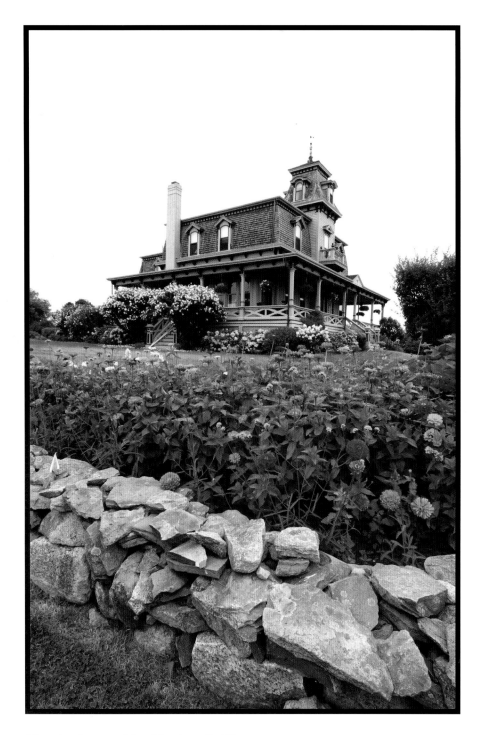

Victorian house with widow's walk, Westport

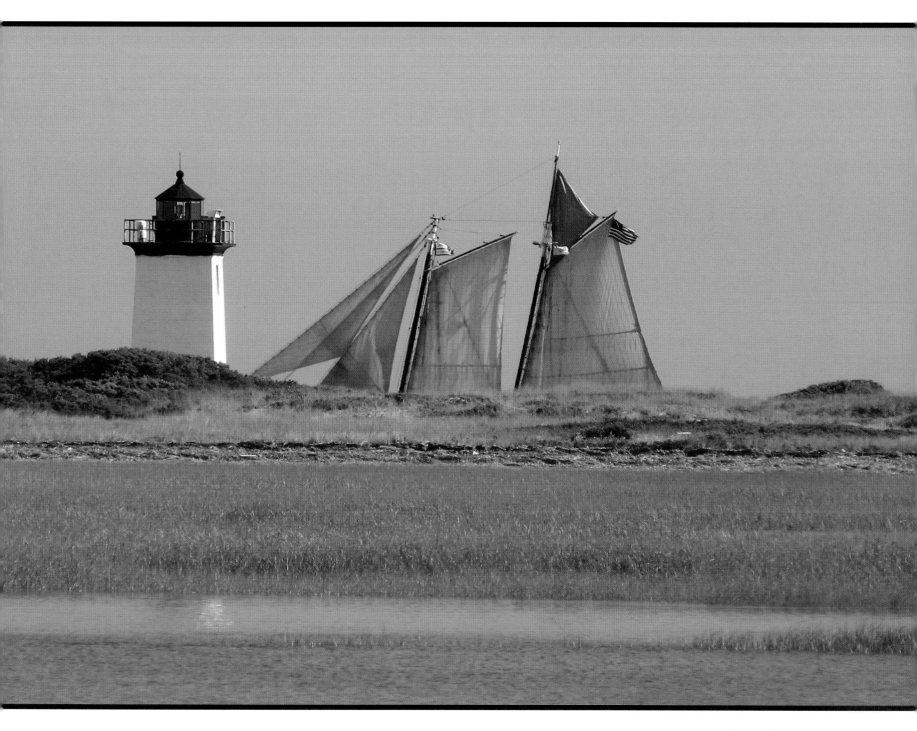

A schooner passing Wood End Light, Provincetown

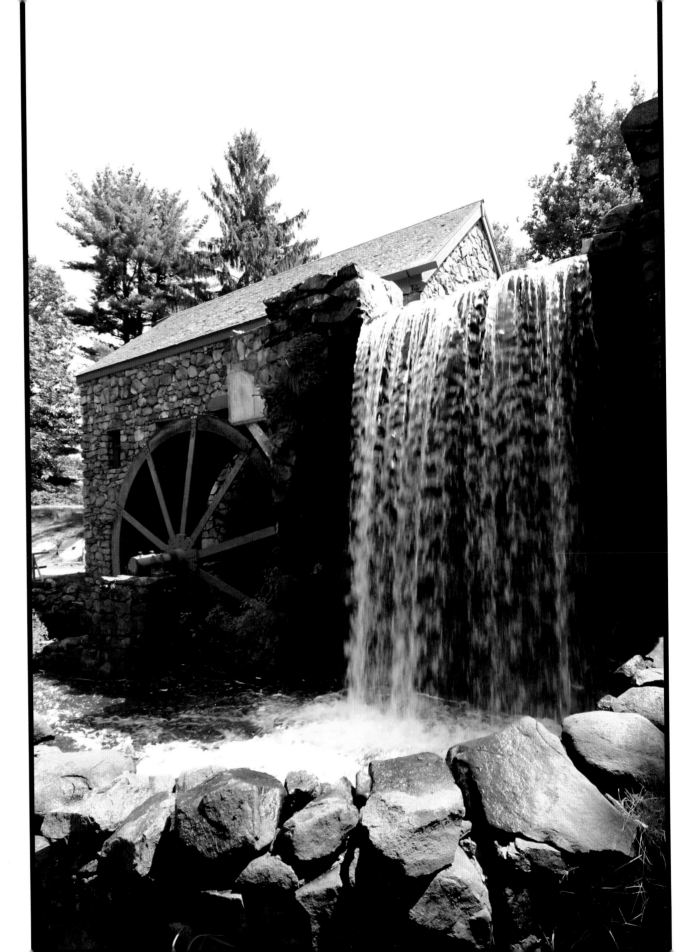

Grist mill at Longfellow's Wayside Inn, Sudbury. Originally a tavern and renamed when Henry Wadsworth Longfellow wrote a poem about it, the inn was purchased in the 1920s by automobile tycoon Henry Ford, who built this working replica of an early mill in 1929.

Left: Turbine model at Lowell National Historical Park, with Lowell City Hall in background

Below: Reenactment of April 19, 1775, battle between British Redcoats and colonial militiamen at Old North Bridge, Concord

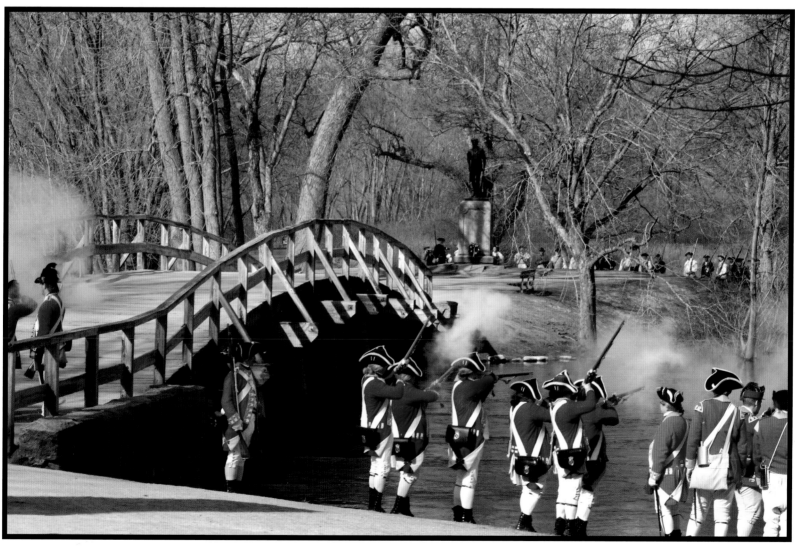

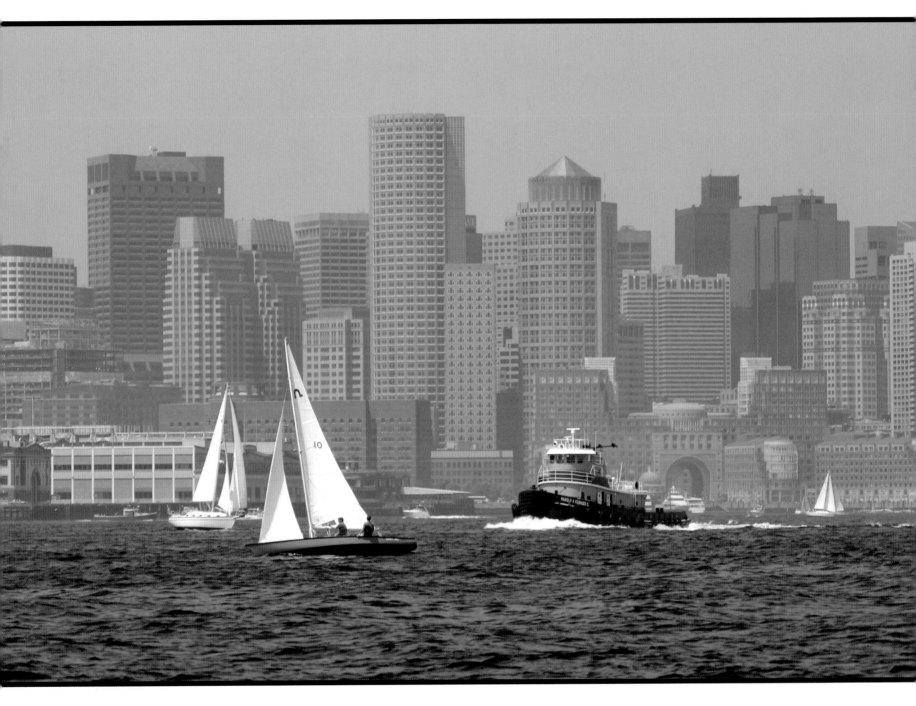

Summer fog on Boston Harbor

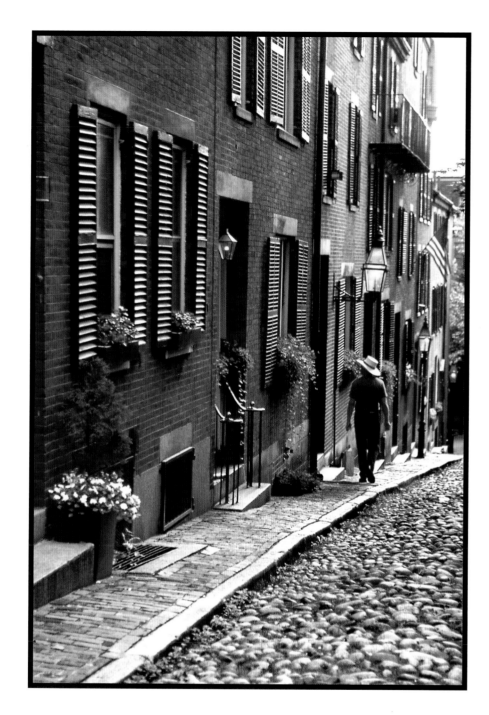

Left: Acorn Street, Beacon Hill, Boston
Below: Offloading catch of the day,
Boston Fish Pier

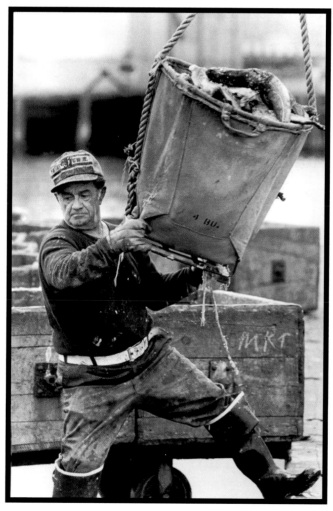

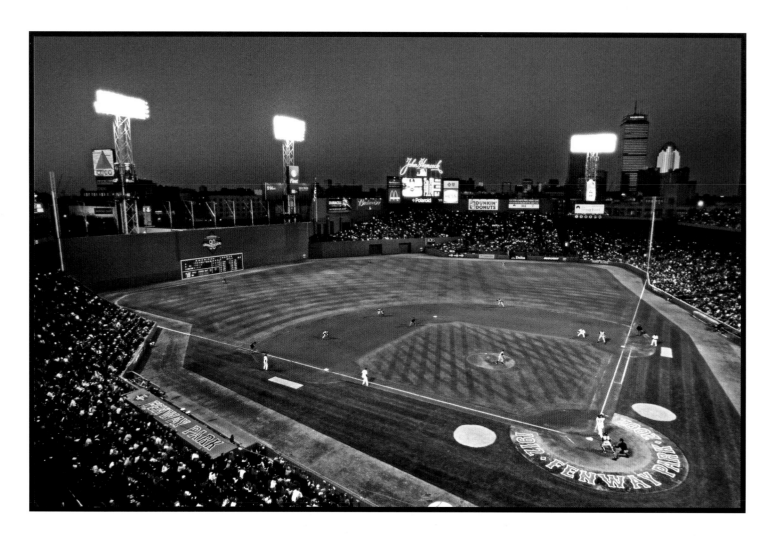

Above: Red Sox game at Fenway Park, Boston

Right: Swan Boats line up for passengers in Boston's Public Garden. This tradition dates to the 1870s, when Robert Paget, whose descendants continue to operate the business, was granted a license by the city. The swans were inspired by the opera *Lohengrin*, in which a knight crosses a river in a boat drawn by a swan to defend the heroine, Princess Elsa.

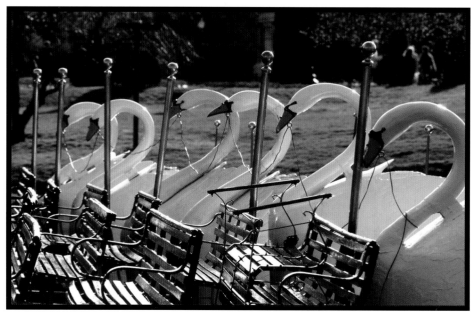

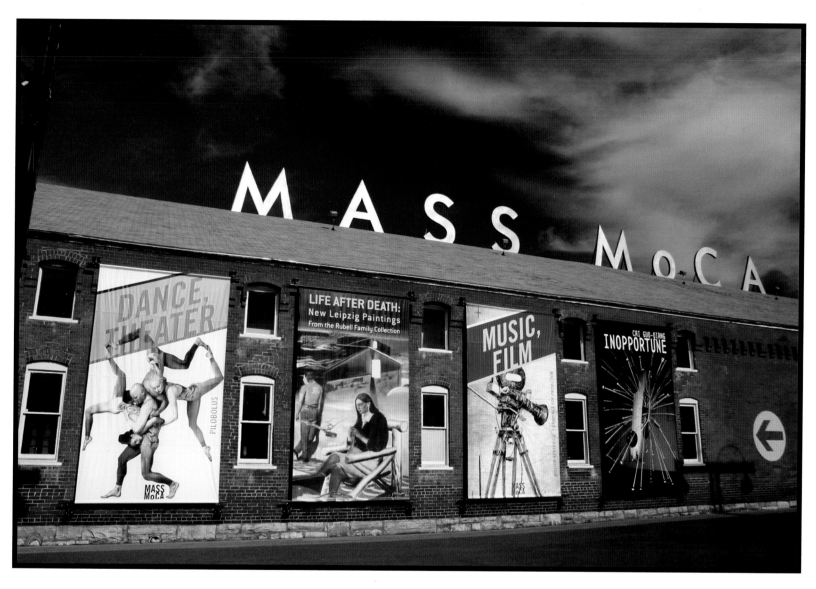

MASS MoCA (Massachusetts Museum of
Contemporary Arts), housed in a sprawling
nineteenth-century factory complex, North
Adams

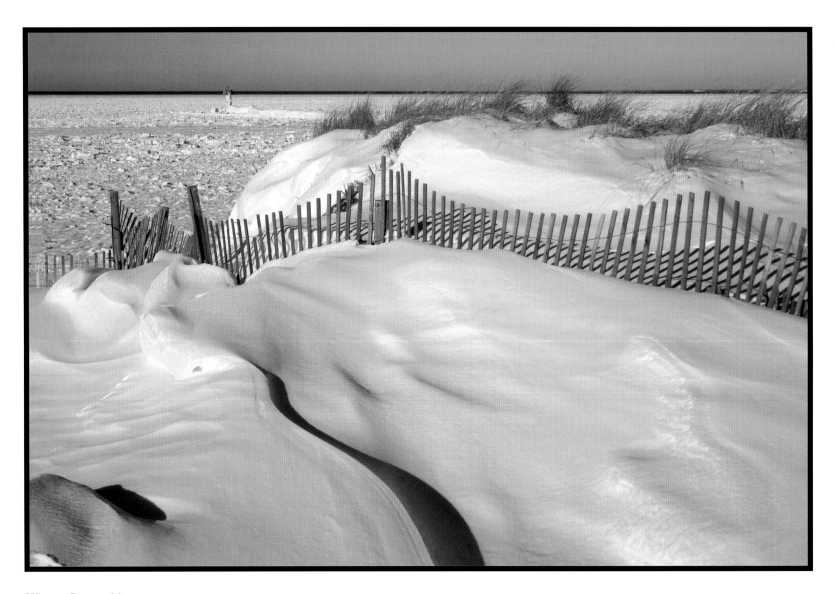

Winter, Barnstable

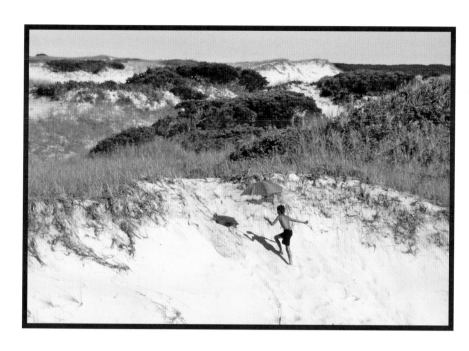

Left: Summer fun, Sandy Neck Beach, Barnstable

Below: Parker River National Wildlife Refuge, Newbury and Rowley

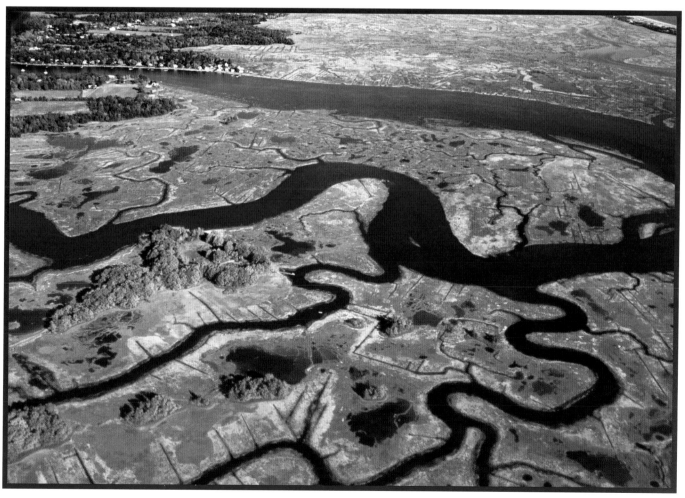

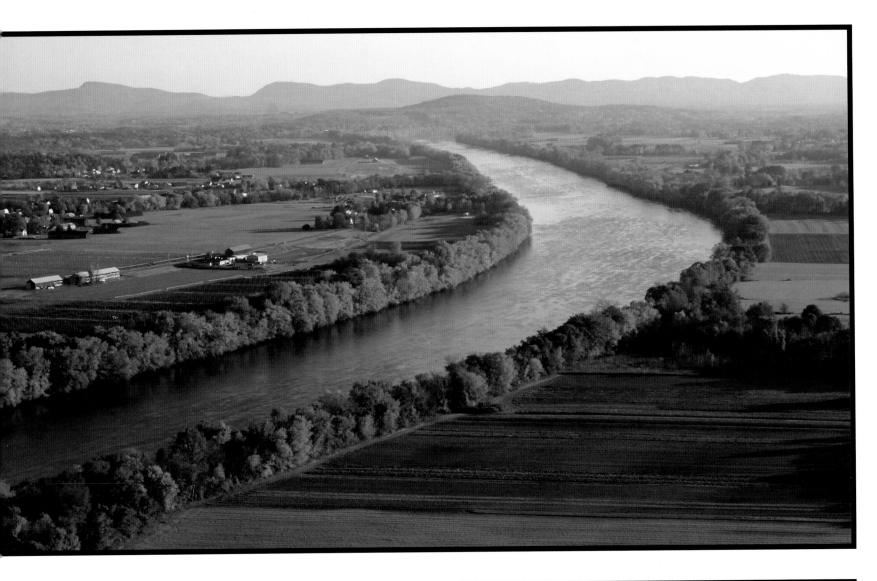

Above: The Connecticut River and Pioneer Valley from Mt. Sugarloaf State Reservation, Deerfield

Right: Gas pumps from the past, Westport

Far right: Sunset at Rock Harbor Beach, Orleans

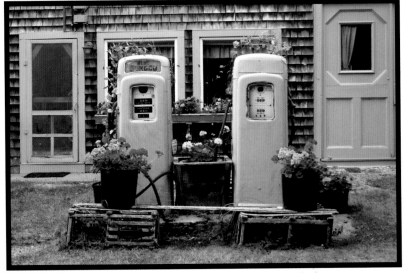

Right: Farmer and Belgian workhorse, Sherborne

Below: Cupola of historic Faneuil Hall amid modern office buildings, Boston

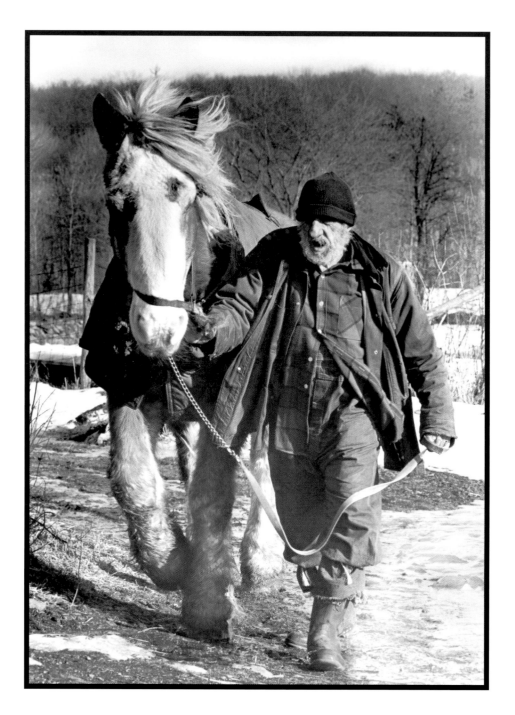

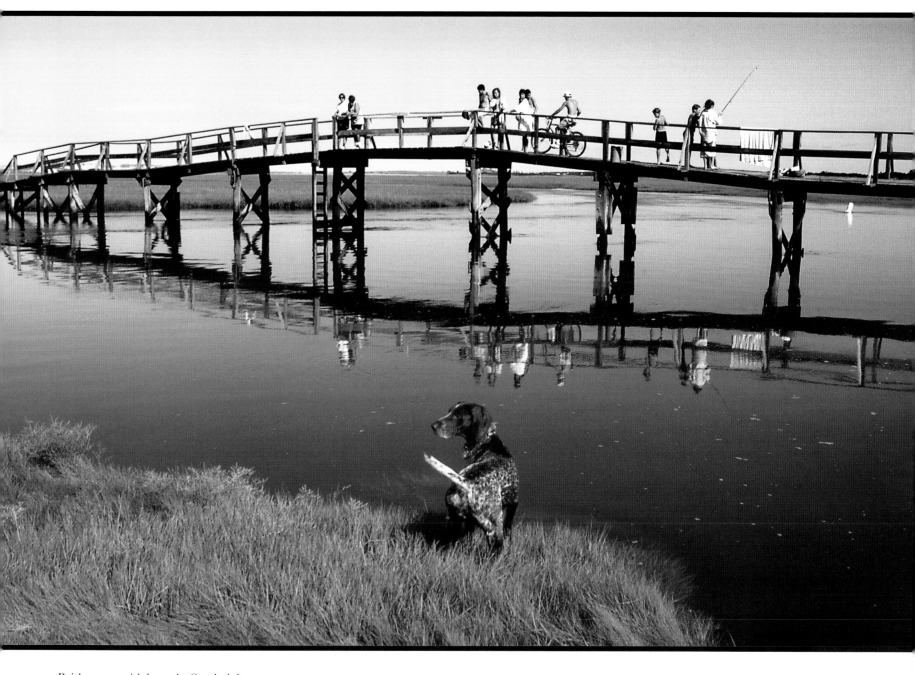

Bridge over tidal creek, Sandwich

Above: Inn, Provincetown
Right: Seafood restaurant, Orleans

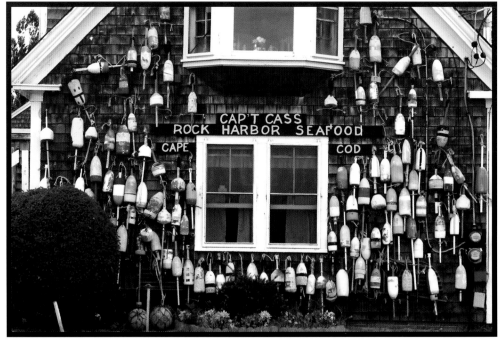

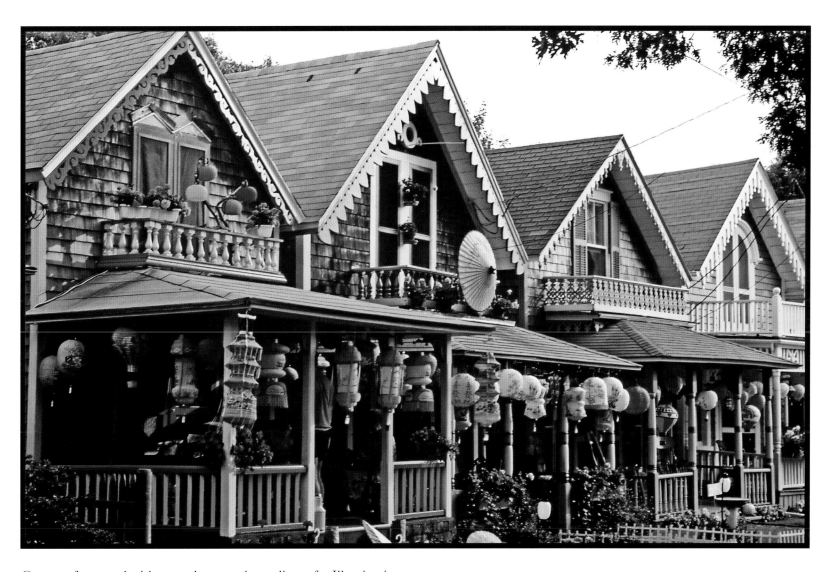

Cottages festooned with paper lanterns, in readiness for Illumination
Night, an annual treat in Oak Bluffs, Martha's Vineyard

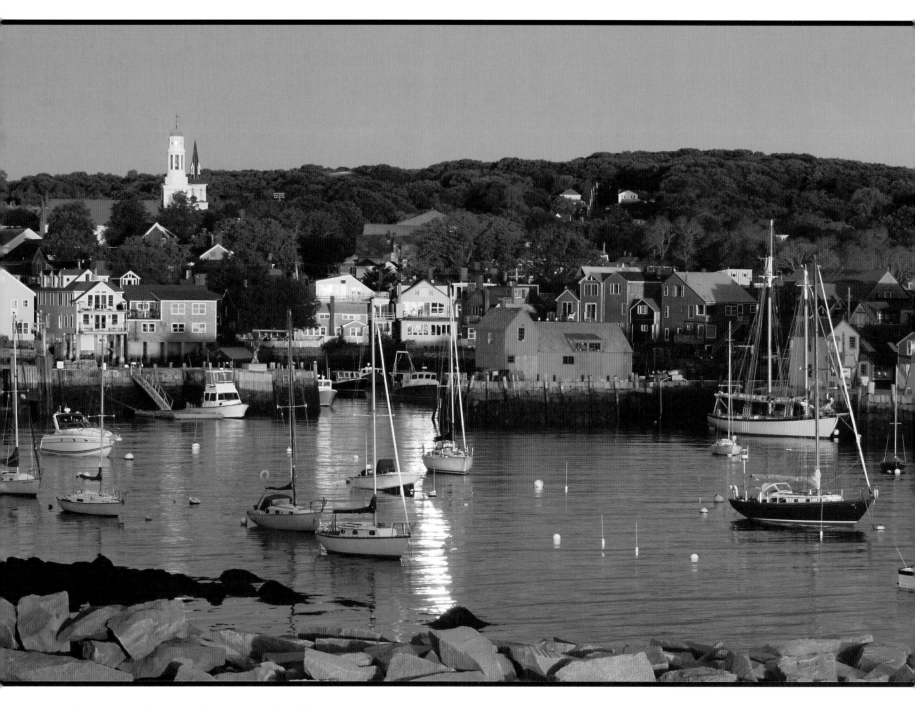

Sunrise over Rockport Harbor, with Motif #1,
America's most-painted image, on Bradley Wharf at
center

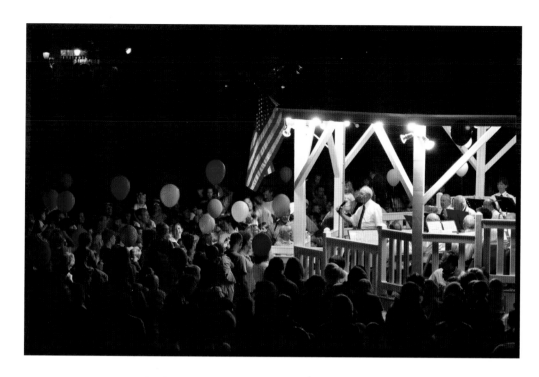

Left: Friday evening bandstand concert, Chatham

Below: Equestrian warm-up, Hamilton

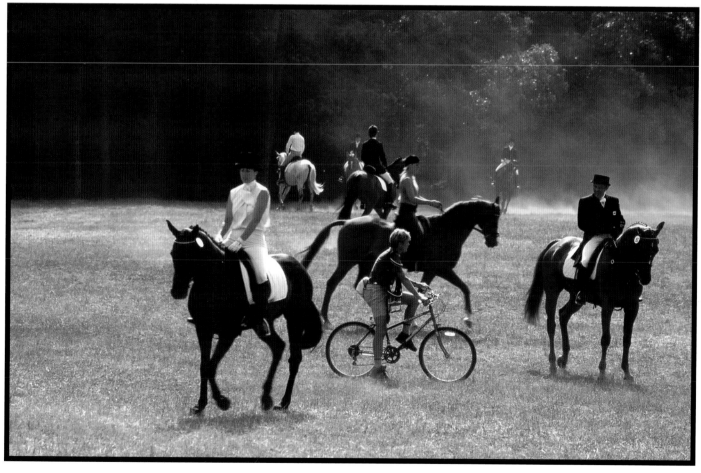

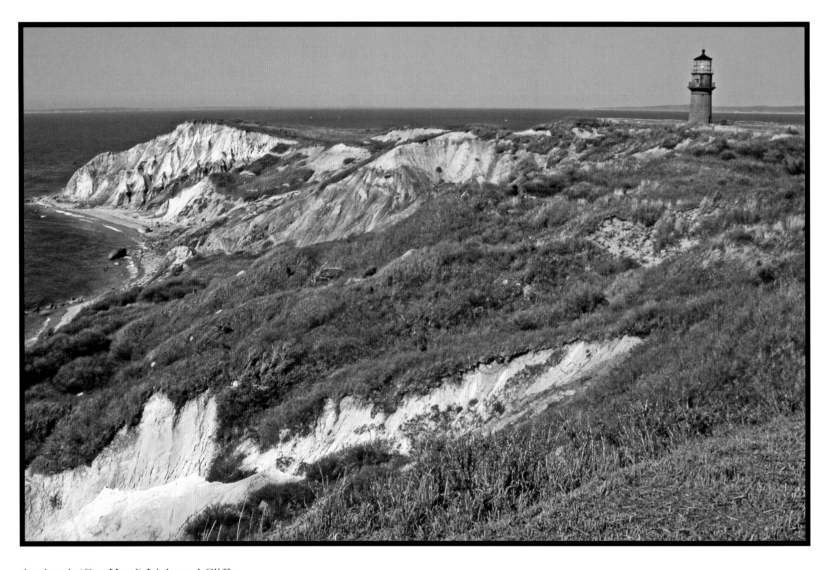

Aquinnah (Gay Head) Light and Cliffs,
Martha's Vineyard

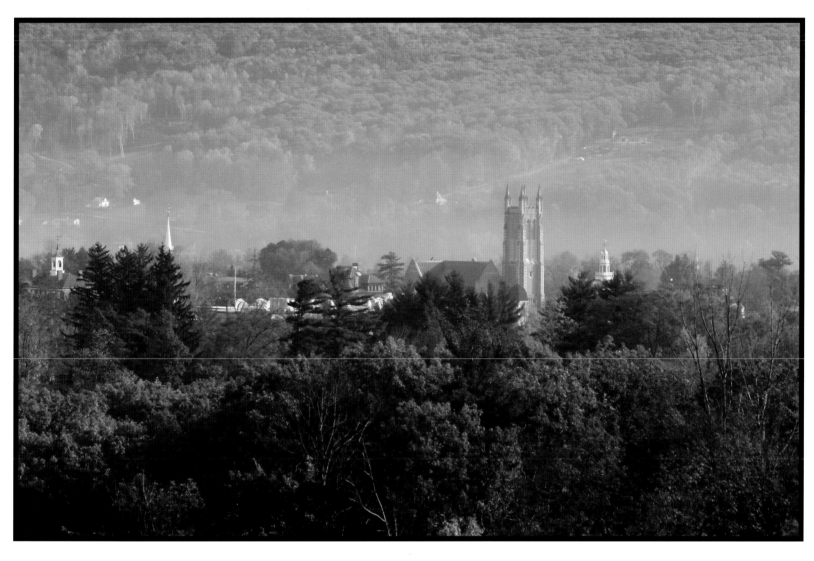

Early morning fog at Williams
College, Williamstown

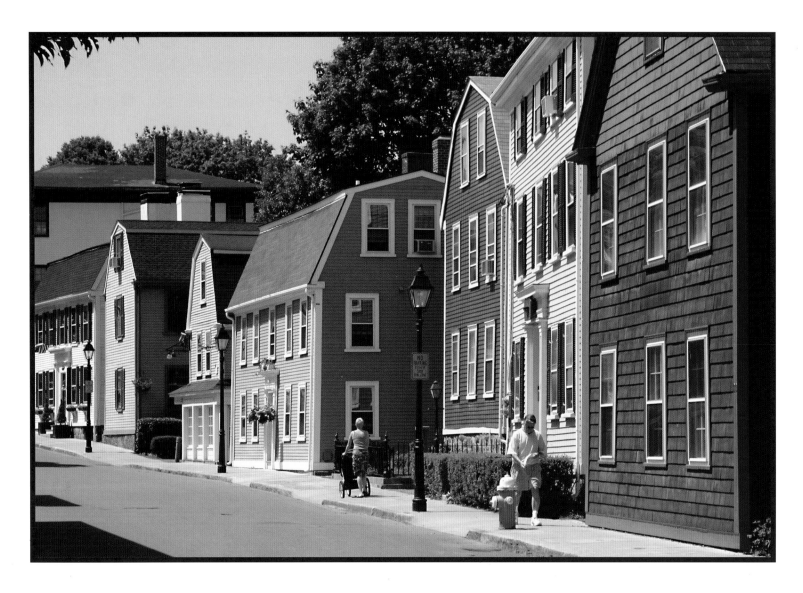

Above: State Street, Marblehead

Right: Reenactment of Pilgrim dinner, Plimoth
Plantation, Plymouth

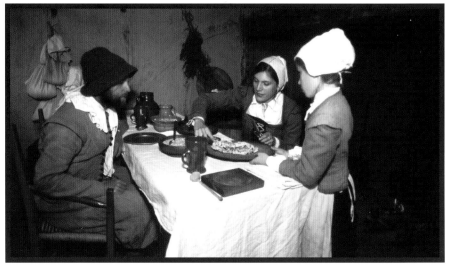

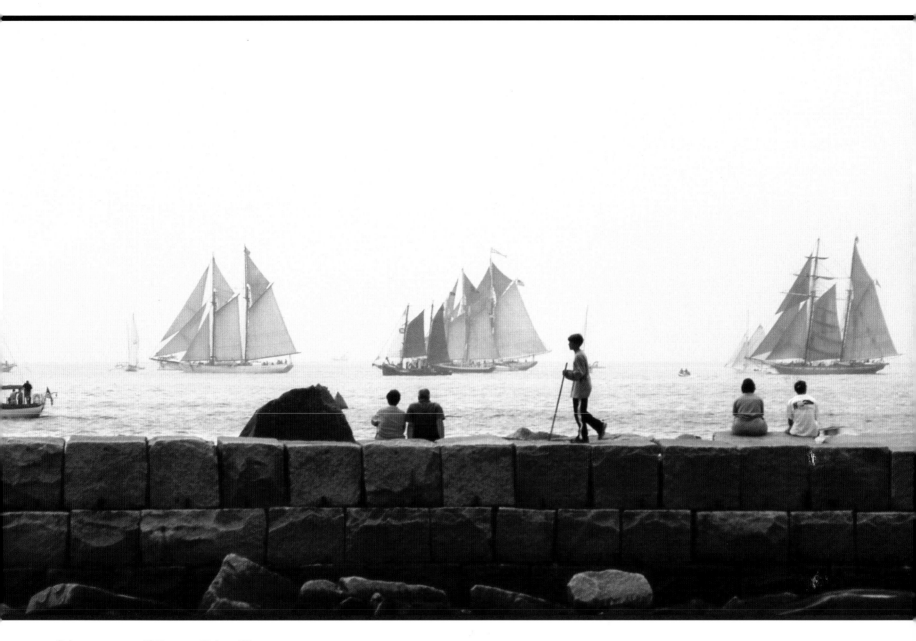

Schooner race off Eastern Point, Gloucester

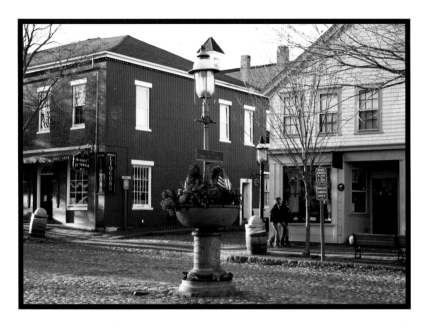

Left: Lower Main Street, Nantucket
Below: Weathered barn with winter berries, Nantucket
Right: Head of the Charles Regatta, Charles River, Cambridge

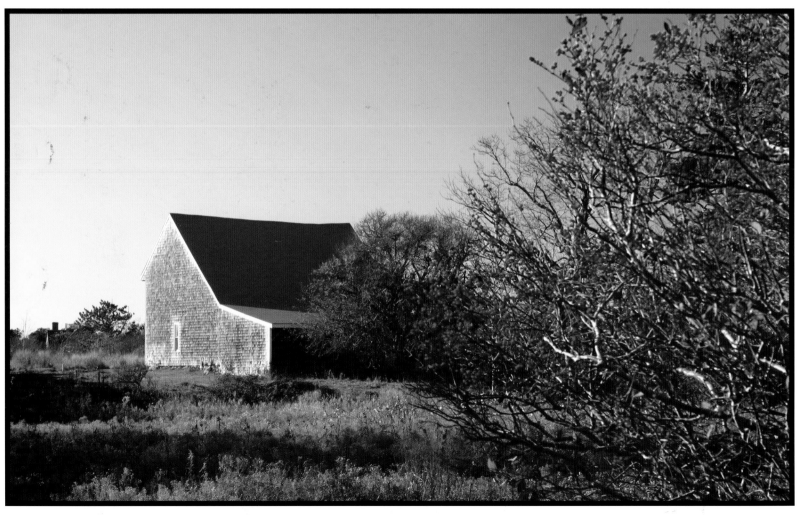

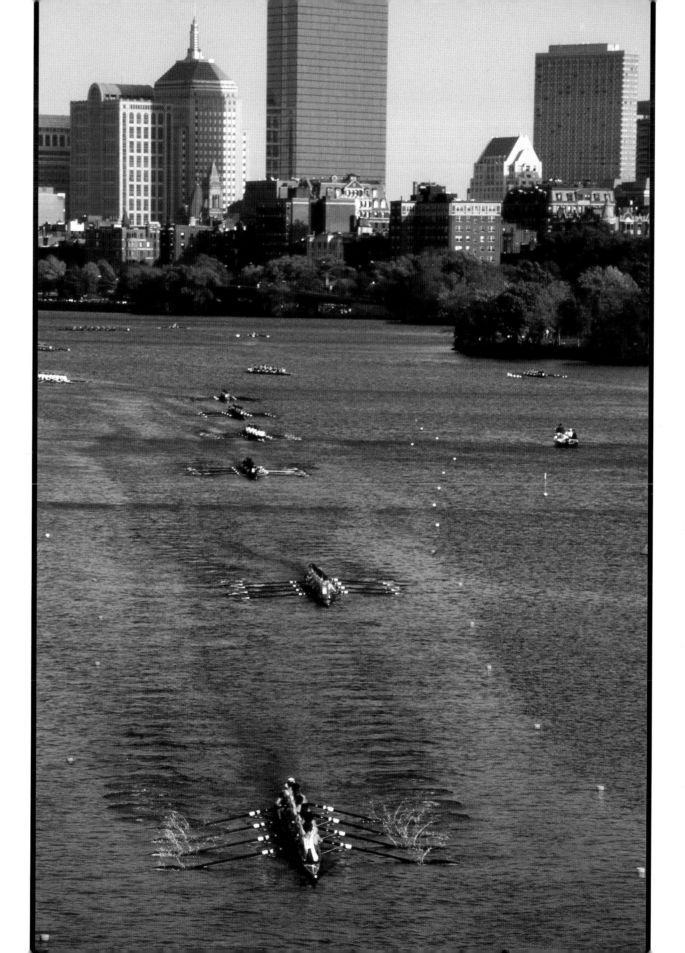

VERMONT

The sun was setting on Lake Champlain. I visited a Morgan Horse farm, saw fall at its best in quaint villages, climbed to the top of Mt. Mansfield in deep snow, saw farms and scarecrows, windmills, the Tunbridge Fair, and country stores. And I tried the cheese!

Opposite: New snow in maple syrup season
Below: Fool on the Hill Gift Shop, Quechee

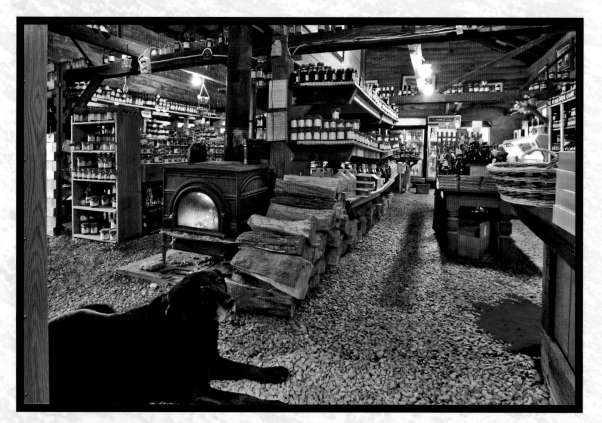

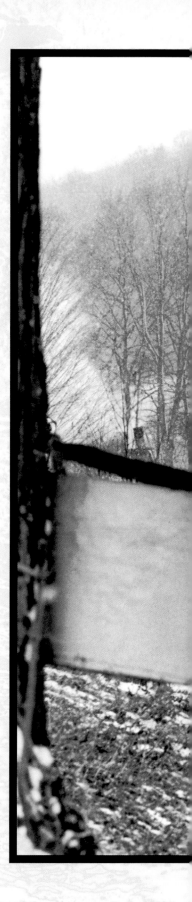

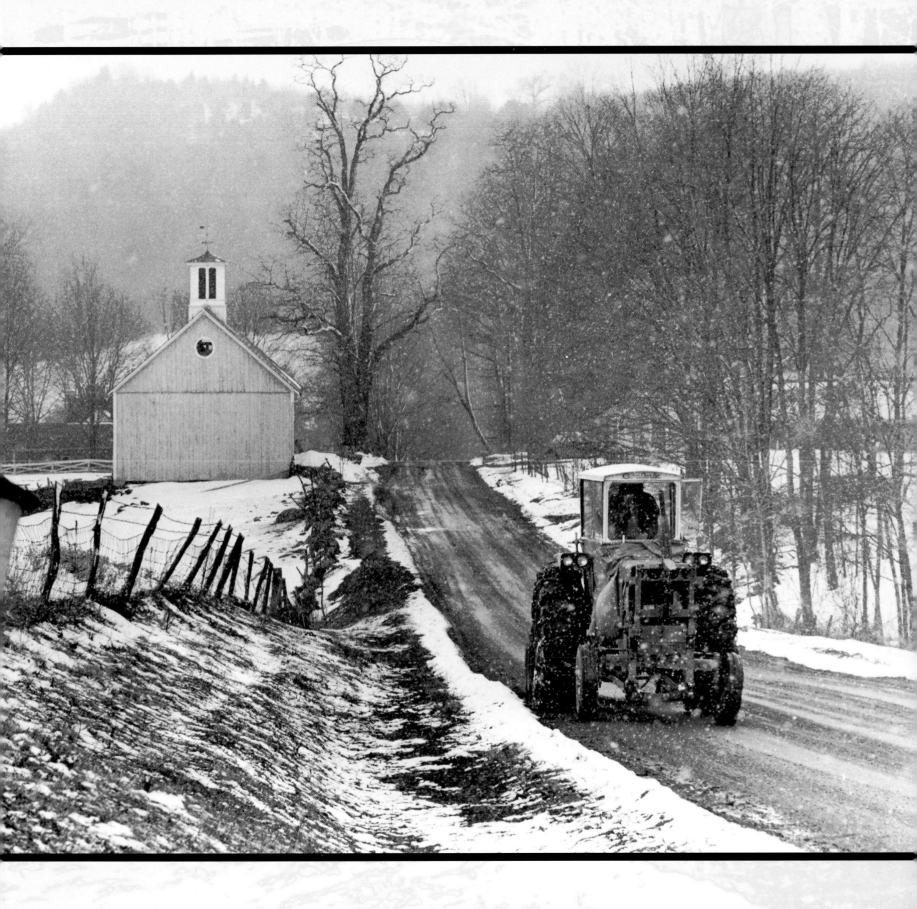

Director riding with student at the
University of Vermont Morgan Horse
Farm, Weybridge

Right: Chopping wood for winter, Strafford
Below: Early autumn cycling, Waitsfield

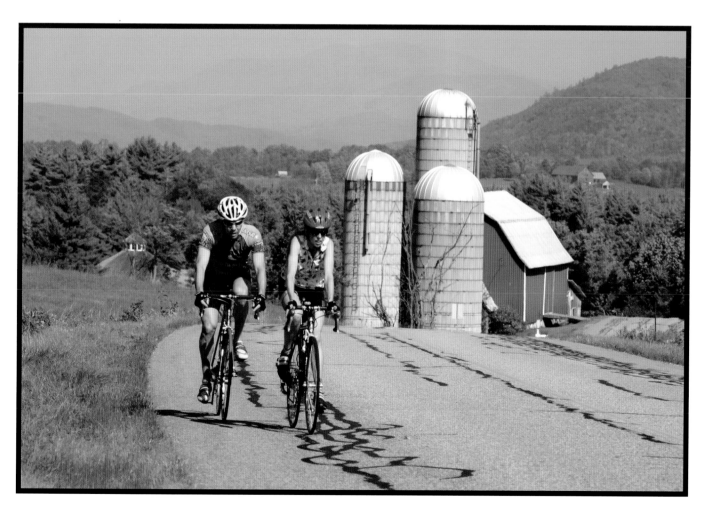

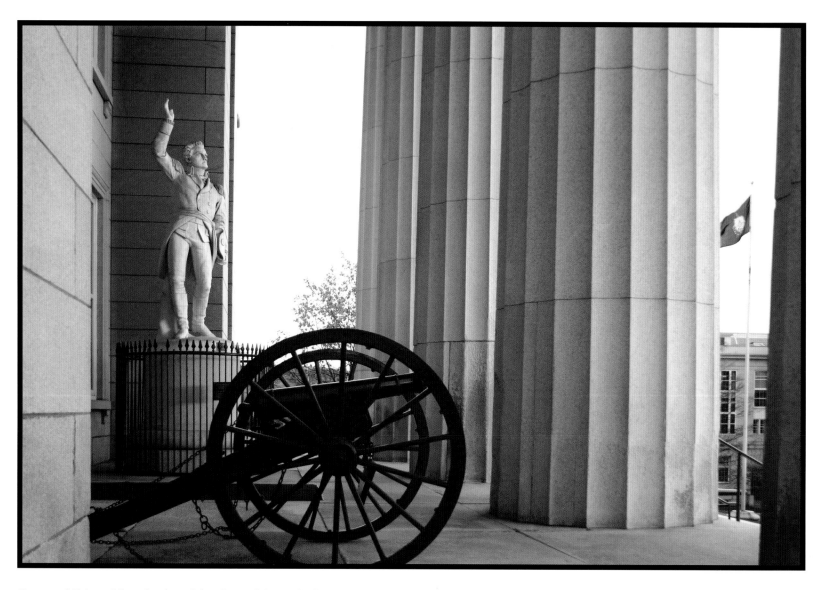

Statue of Ethan Allen, leader of the Green Mountain Boys, on front
portico of Vermont State House, Montpelier,

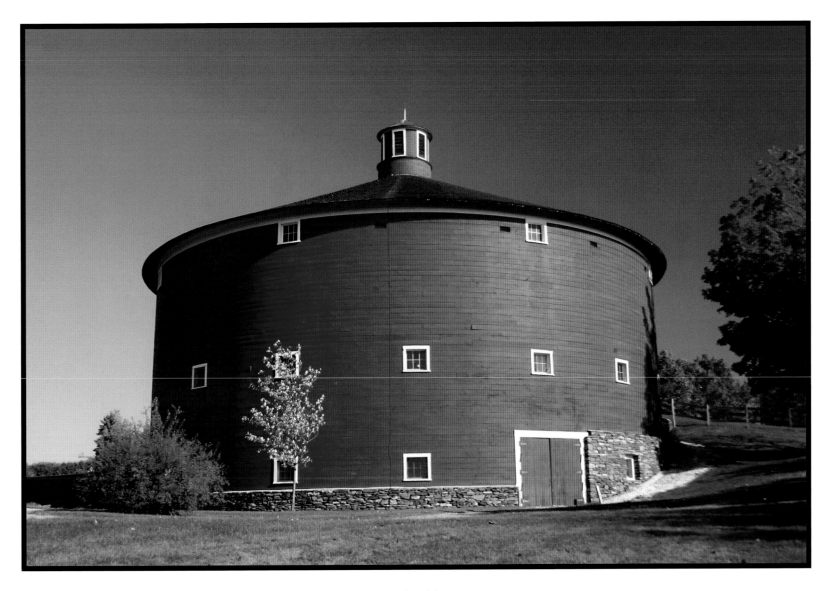

The 1901 Round Barn at Shelburne Museum, Shelburne. The three-level barn
was moved to Shelburne from East Passumpsic, Vermont, and is used for special
exhibitions and admissions.

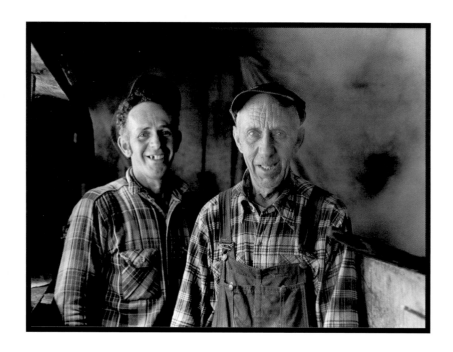

Left: Son and father maple-sugar farmers, Chelsea
Below: Summer view from the top of Mt. Killington

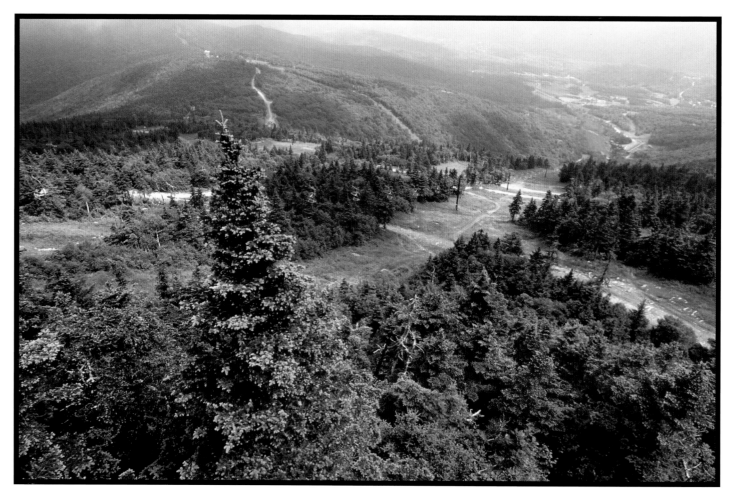

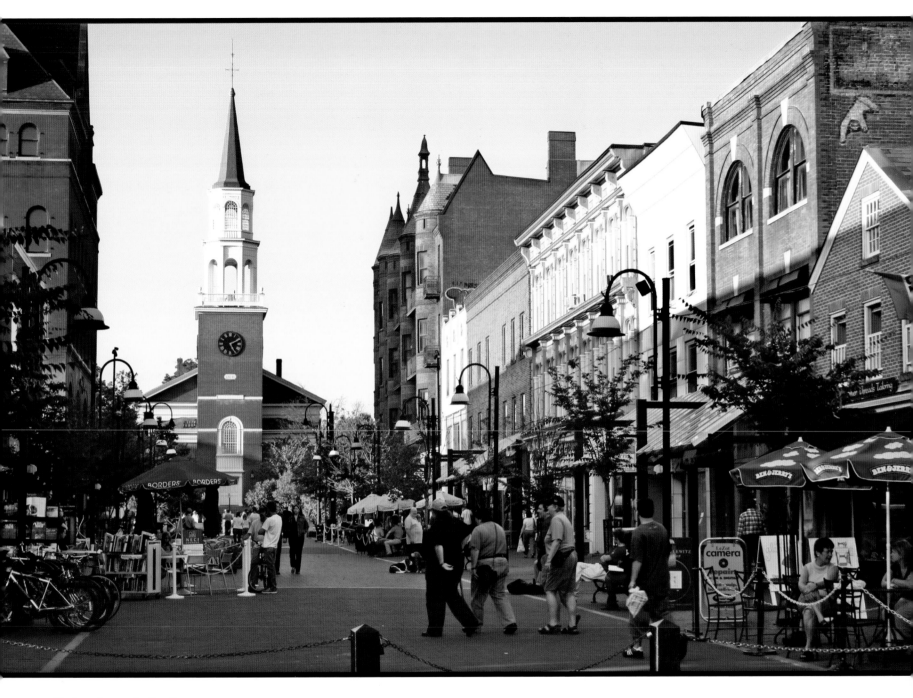

Pedestrian mall, Burlington

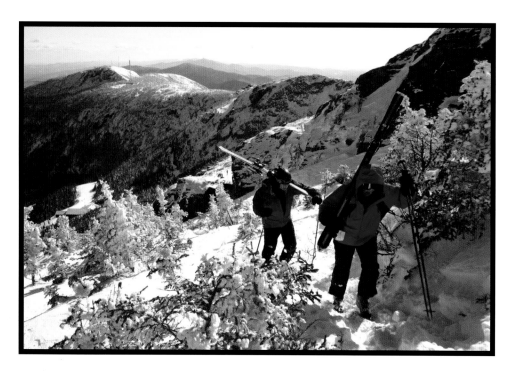

Left: Skiers making their way up Mt. Mansfield, Stowe

Below: Ice sculptures on top of Mt. Mansfield, Stowe

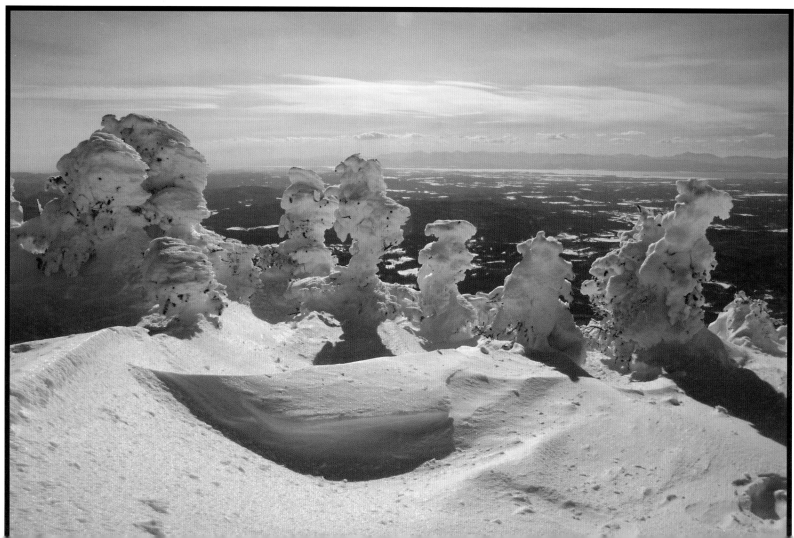

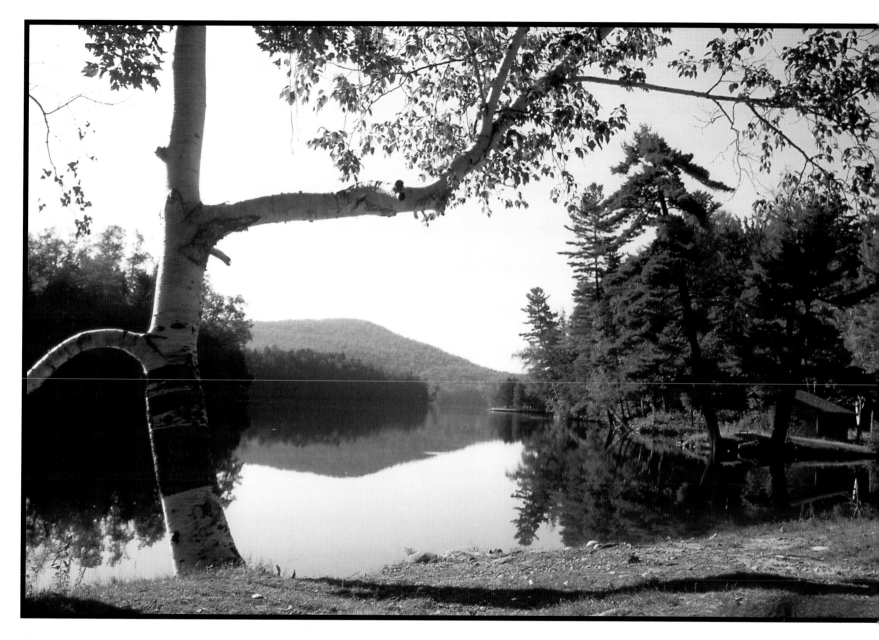

Woodward Reservoir, Plymouth

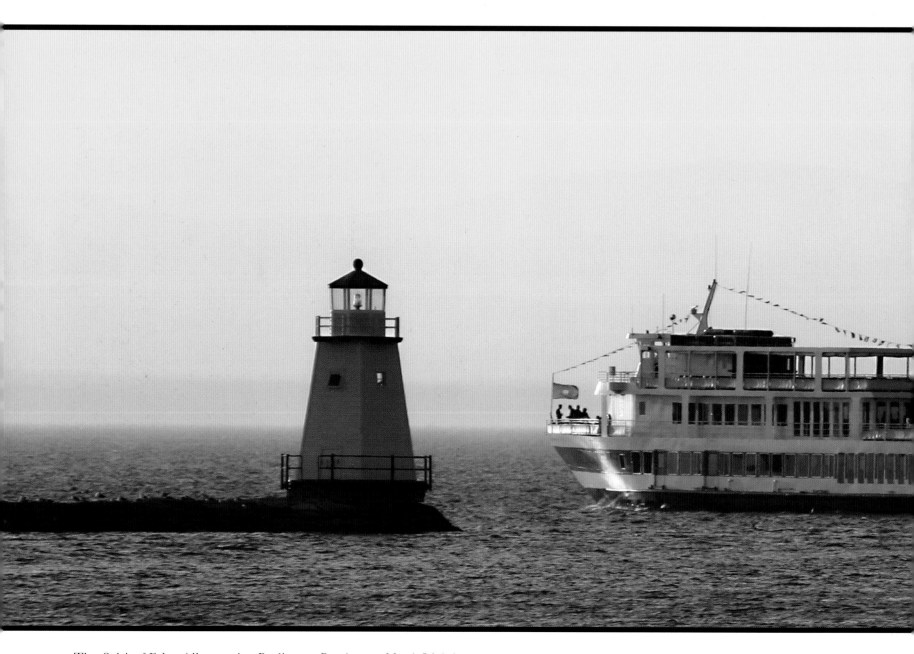

The *Spirit of Ethan Allen*, passing Burlington Breakwater North Lighthouse

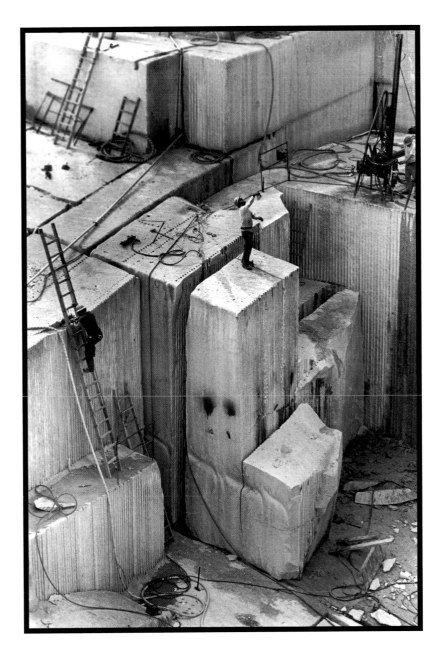

Granite quarry, Barre

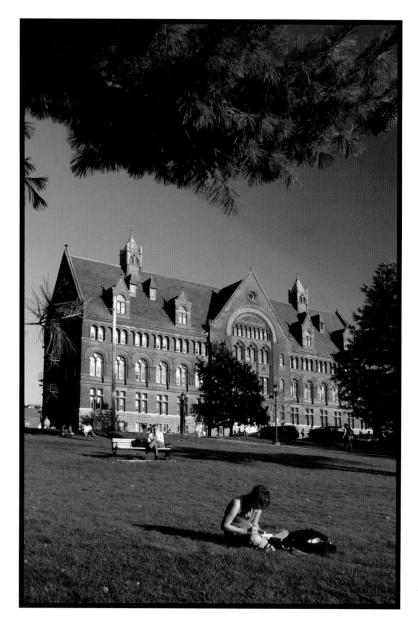

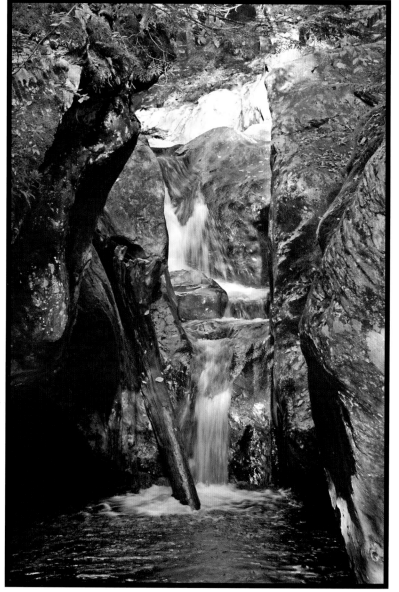

Above: University of Vermont, Burlington
Right: Texas Falls, Green Mountain National Forest

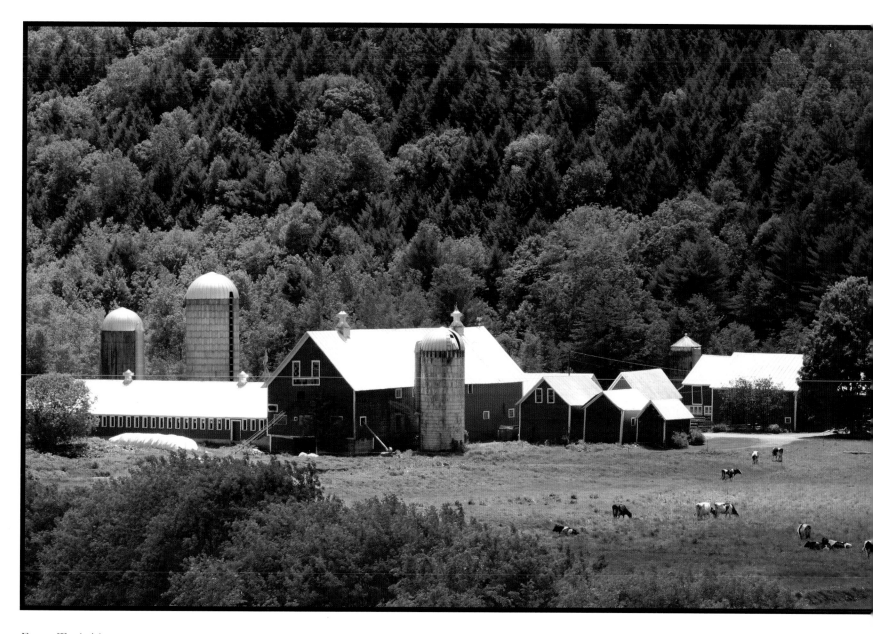

Farm, Tunbridge

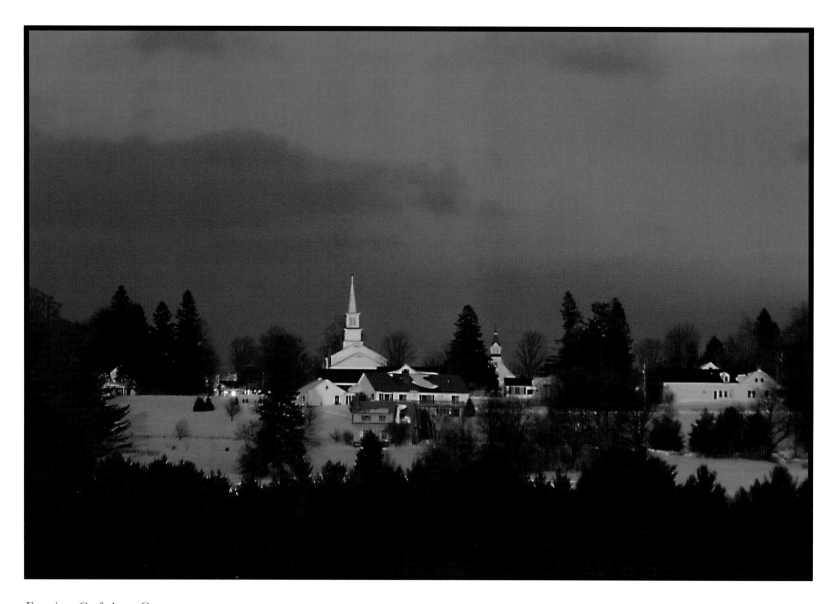

Evening, Craftsbury Common

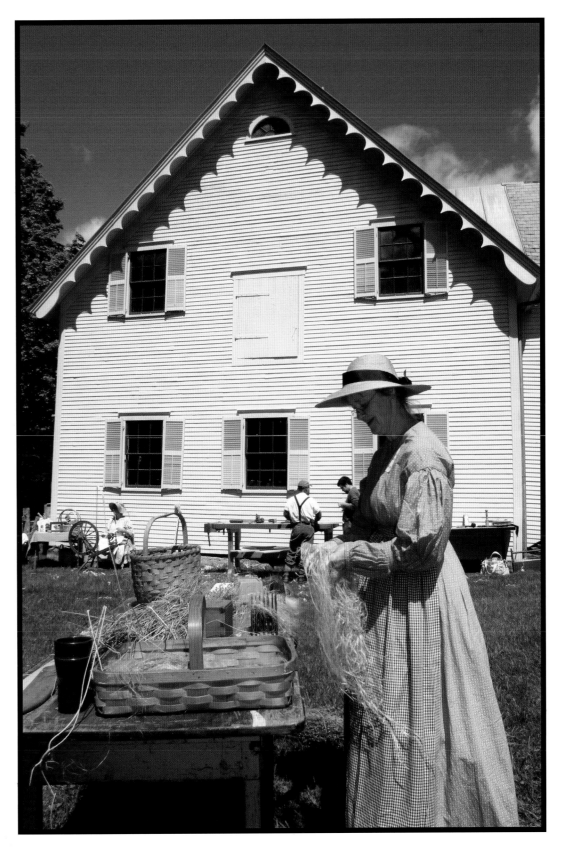

Hatcheling flax at crafts sale, Justin Smith Morrill Homestead

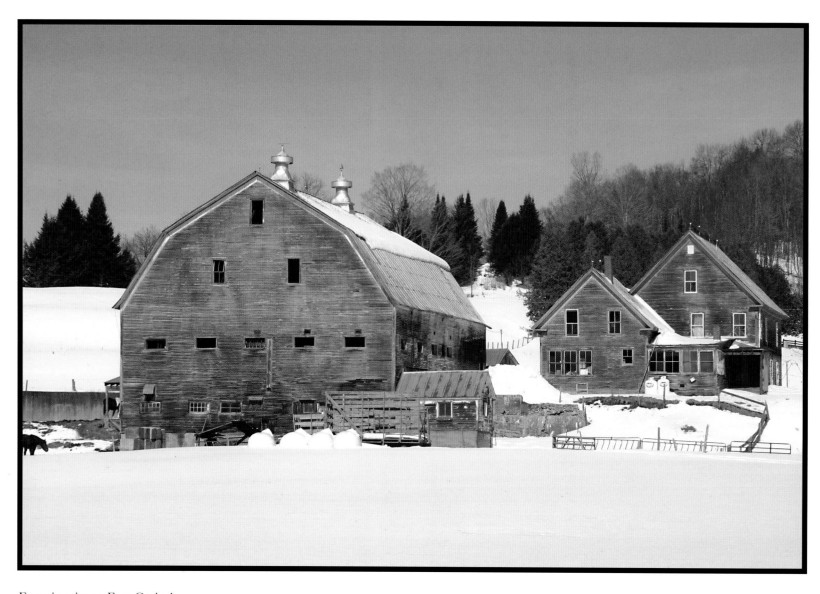

Farm in winter, East Corinth

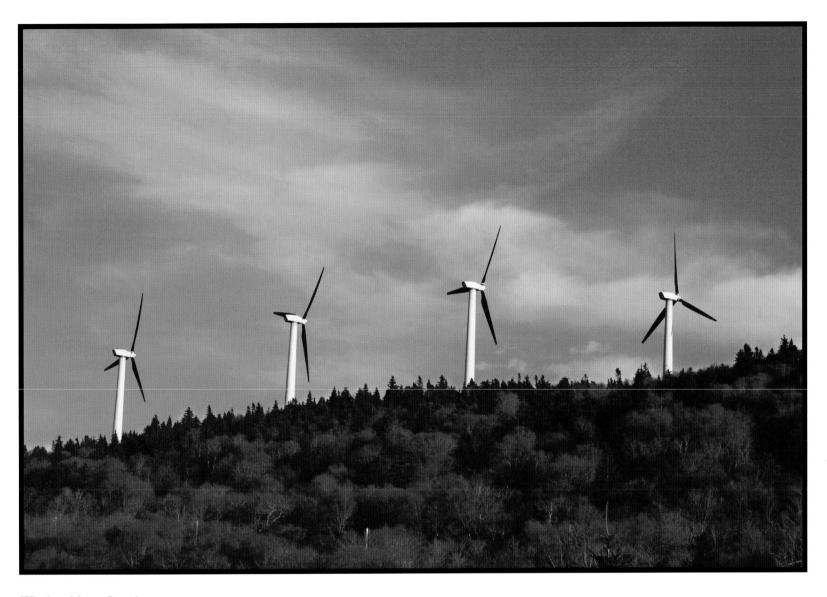

Wind turbines, Searsburg

NEW HAMPSHIRE

I enjoyed the charm of Portsmouth and Strawbery Banke. I hiked in the Presidential Range (I have done so often). I encountered covered bridges, saw balloons rise in the morning fog, gloried in lupines in full bloom on hillsides, and watched a groom and his best man fish before the big event.

Right: Horsecart, Warner
Below: Conway Scenic Railroad, North Conway

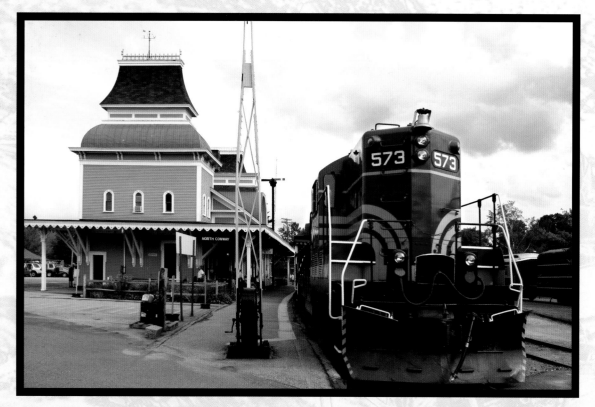

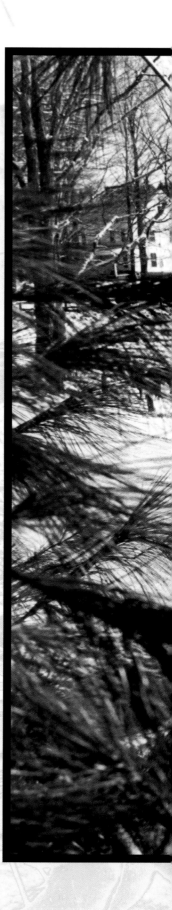

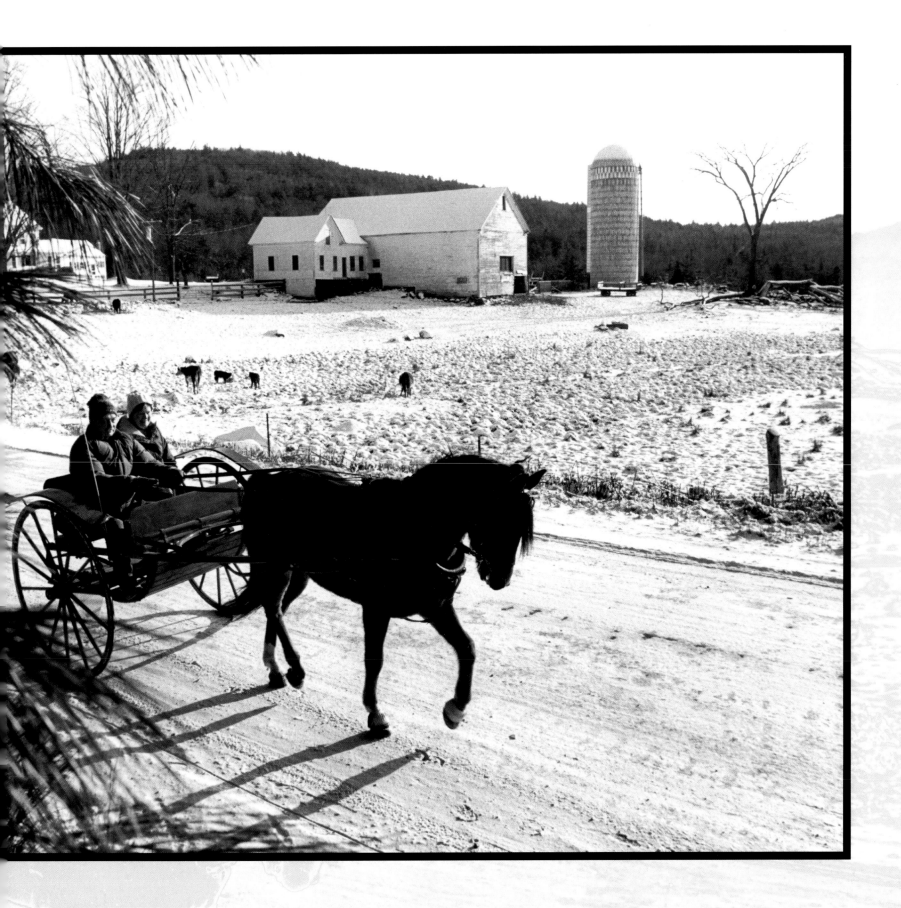

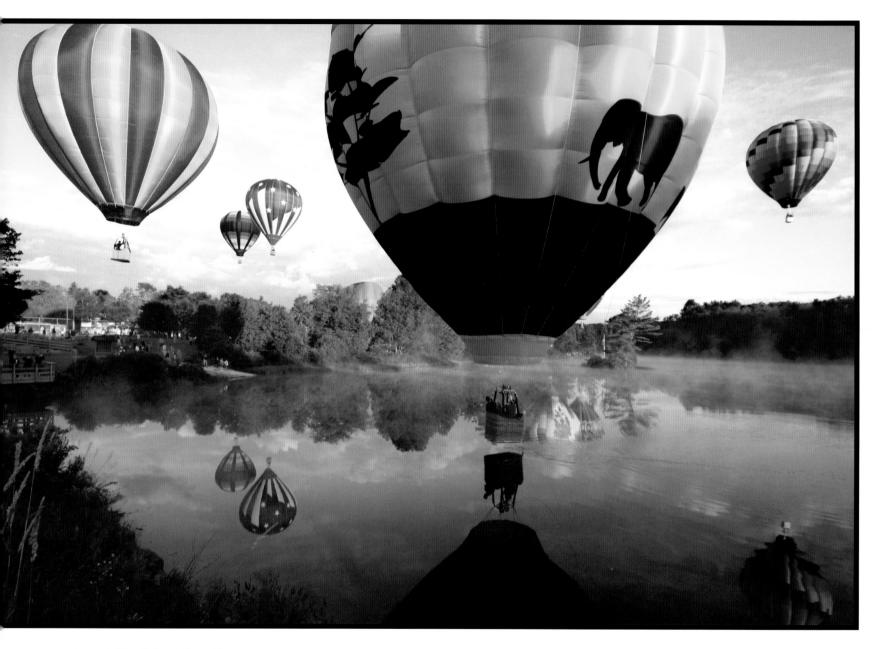

Annual Pittsfield Balloon Festival,
Whites Pond, Pittsfield

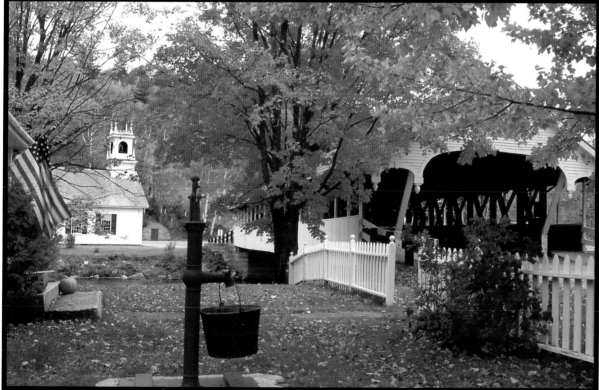

Above: Laconia Motorcycle
Week participants, Meredith

Left: Union Church and
covered bridge, Stark

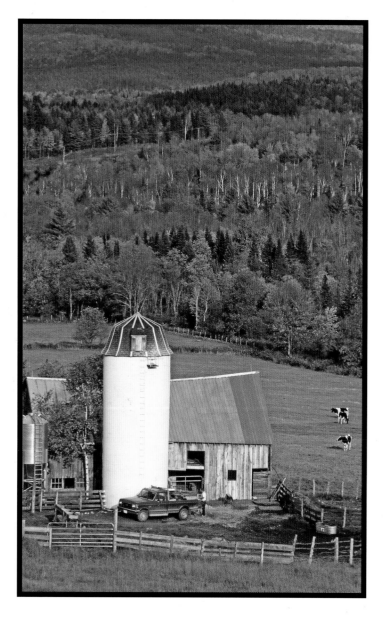

Above: Farm, Lancaster
Right: Mt. Washington Cog Railway

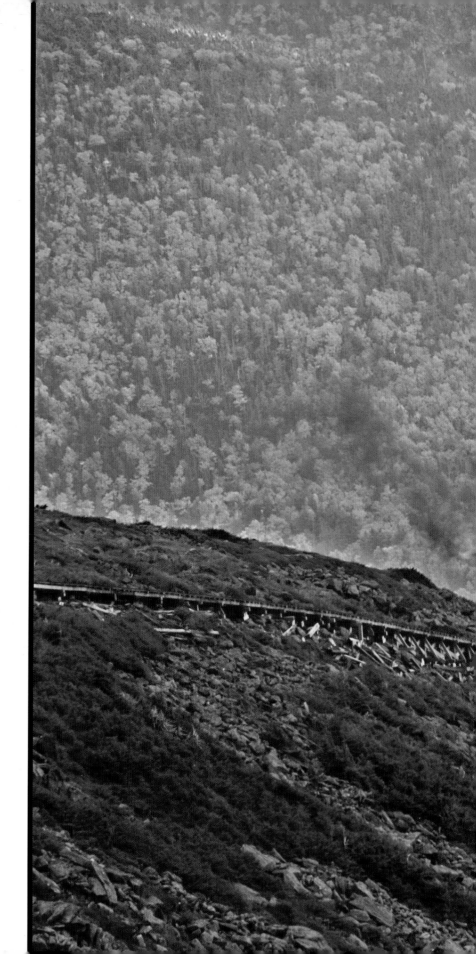

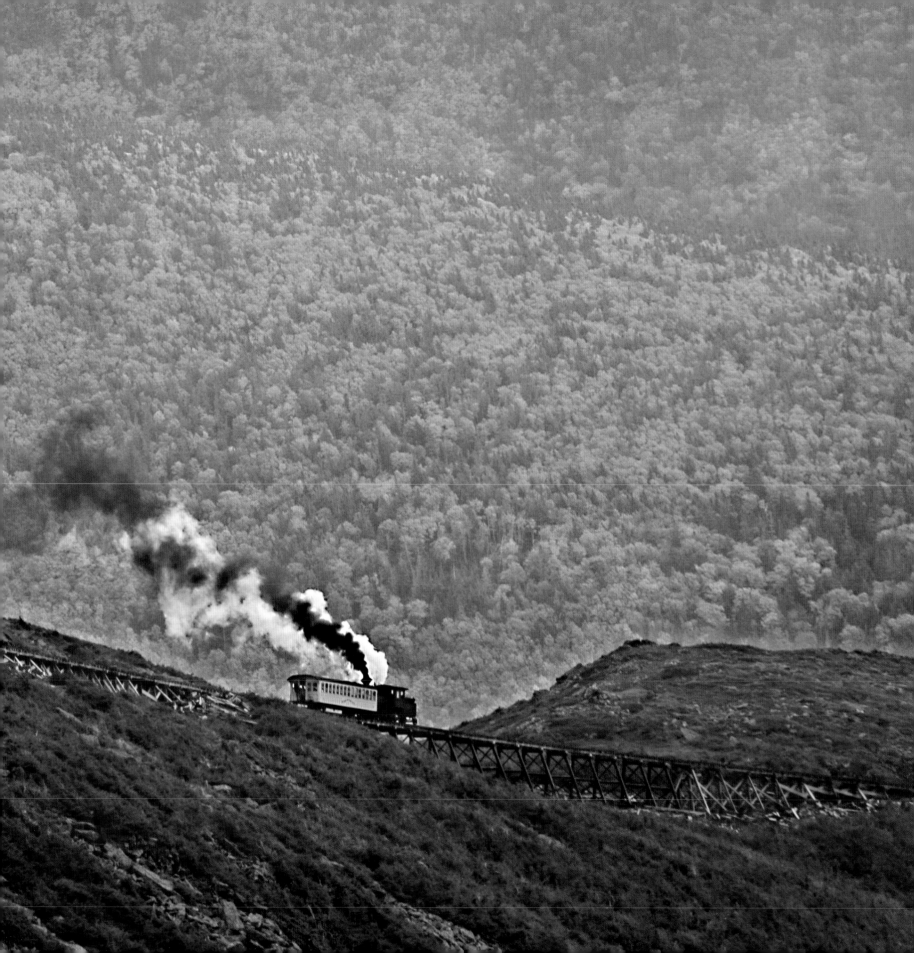

Right: Goose chase, South Weare

Below: Reenactor as Sarah Parker Rice Goodwin tending her garden, Strawbery Banke, Portsmouth

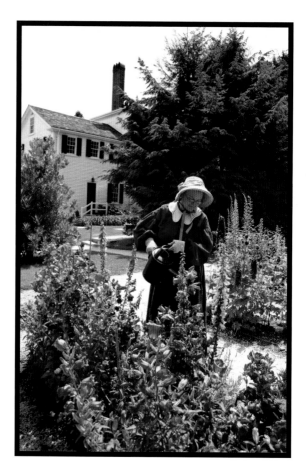

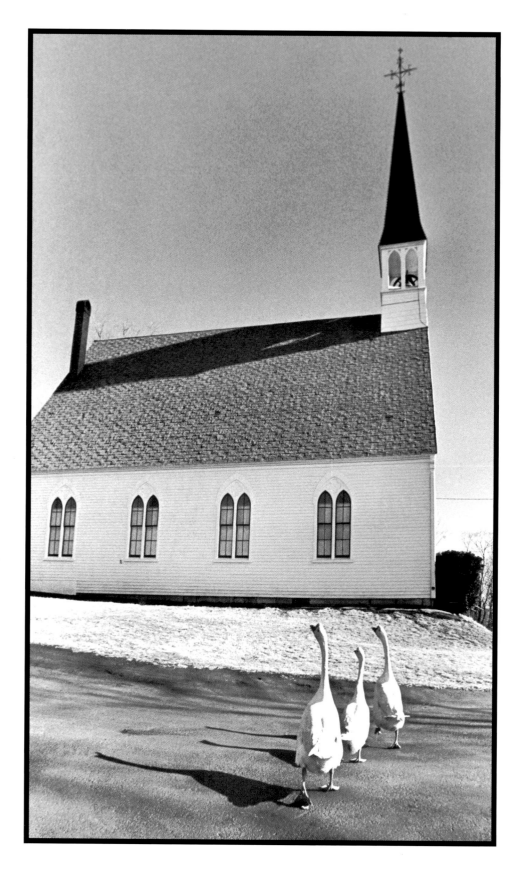

Washington
Congregational Church,
police station, and town
hall (left to right),
Washington

Mailboxes at Lear Hill Bridge, Goshen

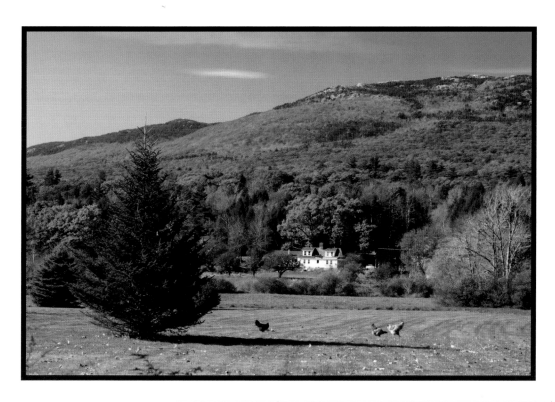

Left: East slope, Mt. Monadnock, Jaffrey

Below: Lupines, Sugar Hill, one of several communities that celebrates an annual Lupine Festival

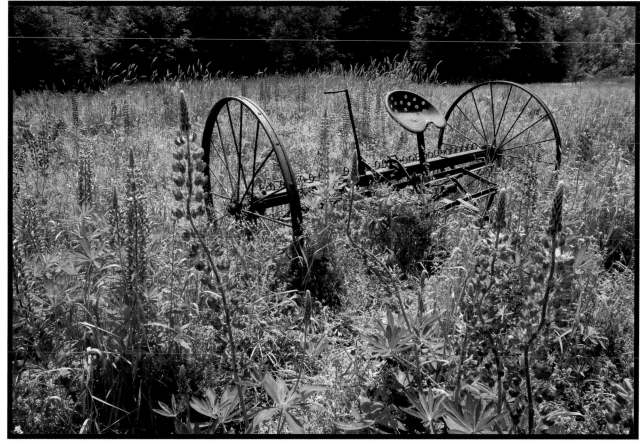

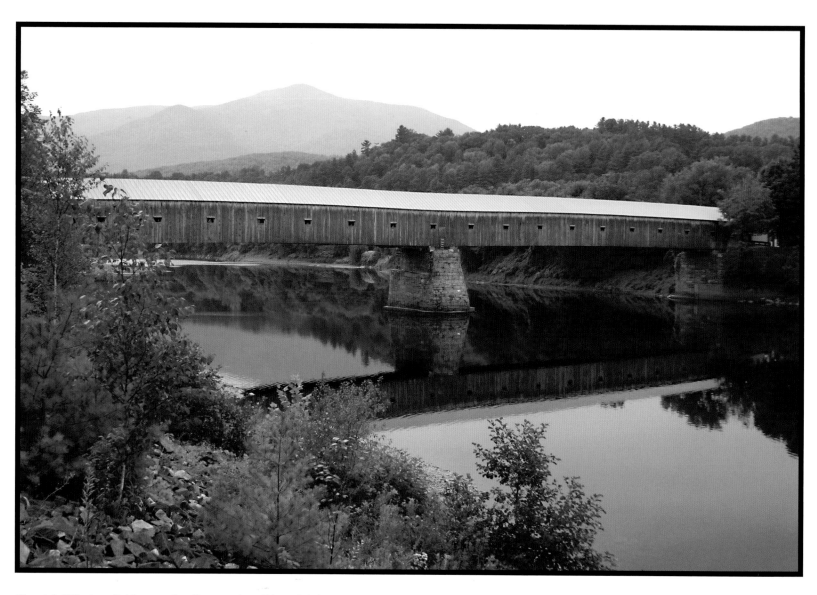

Cornish-Windsor Bridge on the Connecticut River, joining
Cornish with Windsor, Vermont

Sunapee Lake, dusk

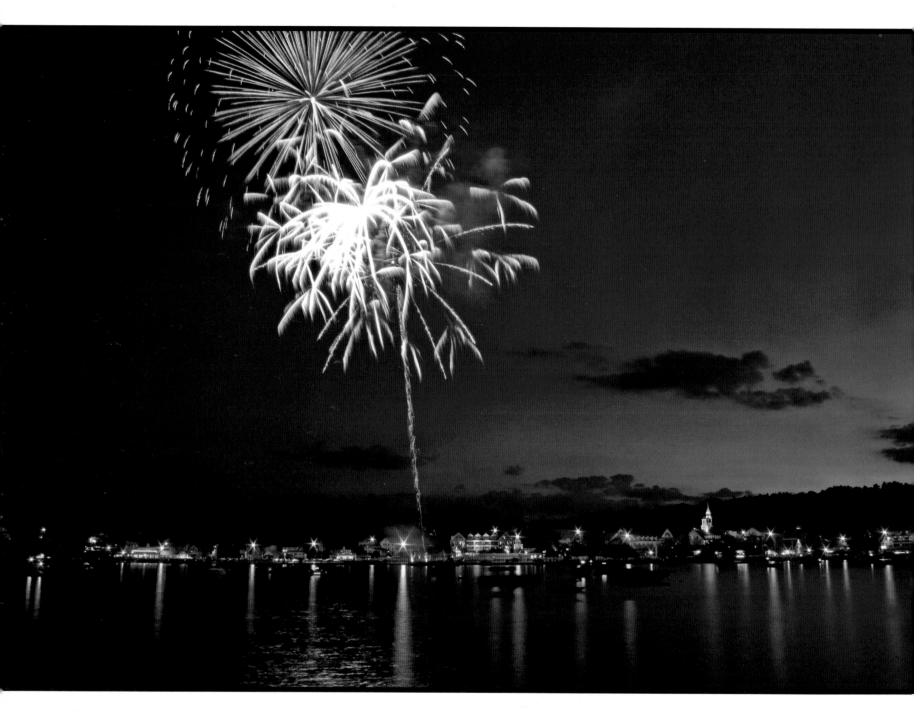

Fourth of July fireworks above Lake
Winnipesaukee, Meredith

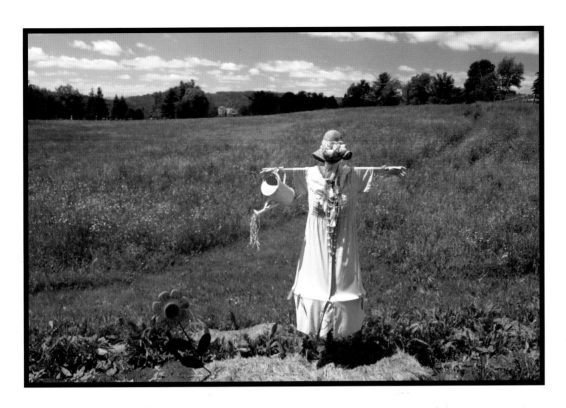

Left: Scarecrow, near Sugar Hill

Below: Saint-Gaudens National Historic Site, featuring the home, gardens, and studios of sculptor Augustus Saint-Gaudens, Cornish

Gristmill, Squam River, from
Ashland Memorial Park, Ashland

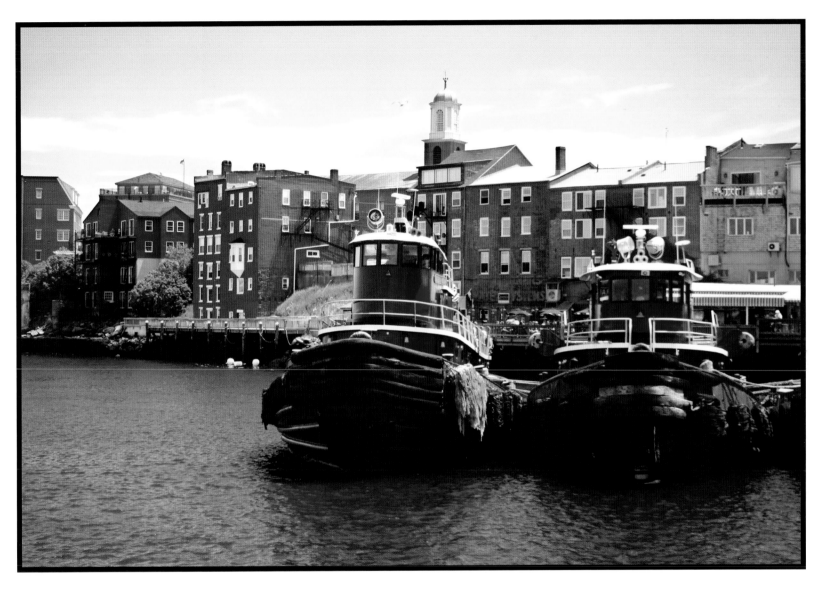

"Tugboat Alley," Piscataqua River,
Portsmouth

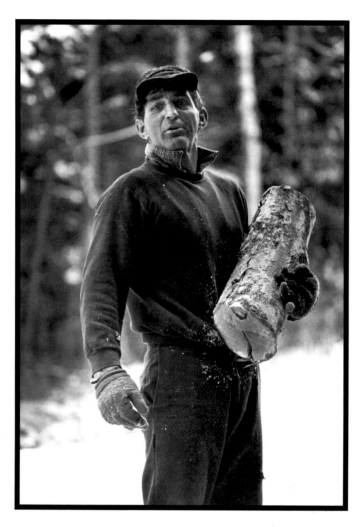

Above: Logger, Contoocook

Right: Early snow, with autumn hanging
on in the valley, Presidential Range

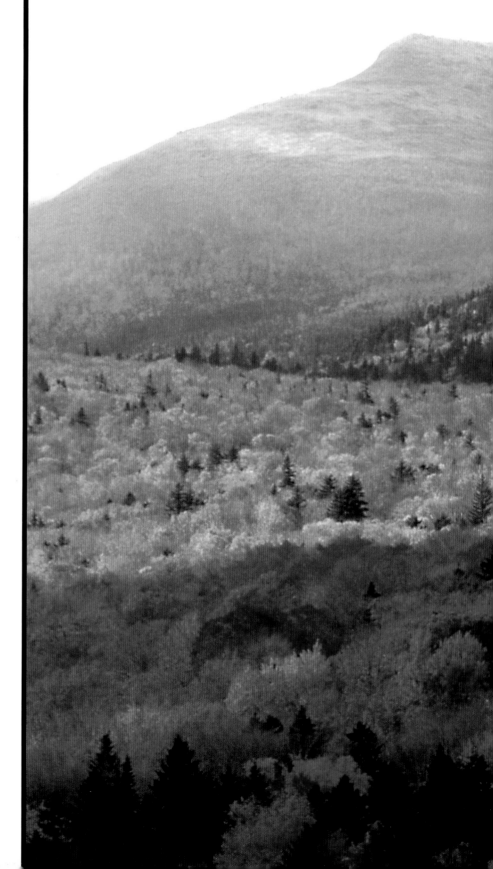

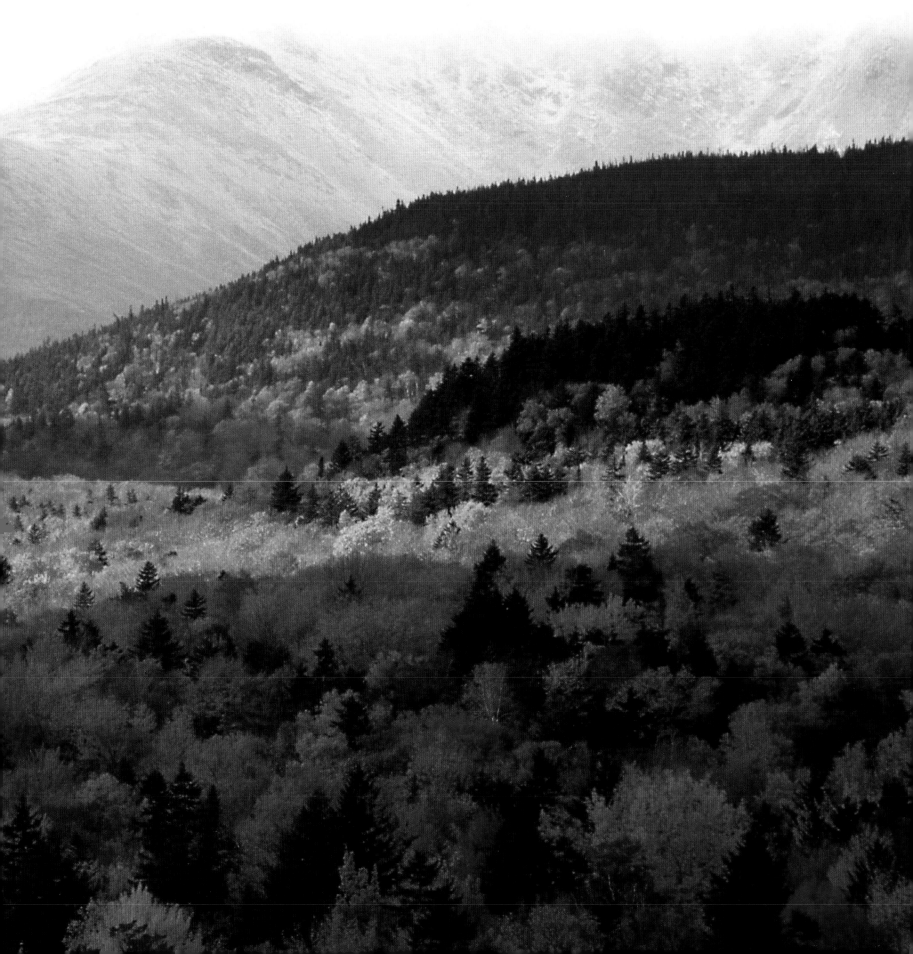

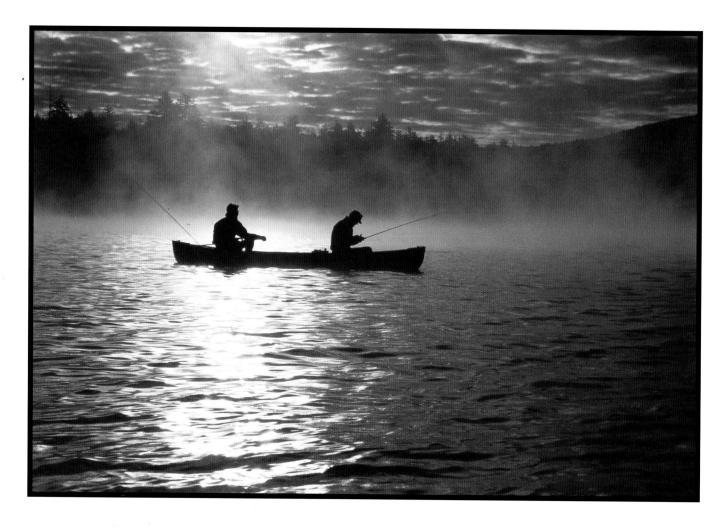

Above: Early-morning fishing on Conway
Lake, North Conway

Right: Cross-country skiers with Presidential
Range in the distance, near Wildcat

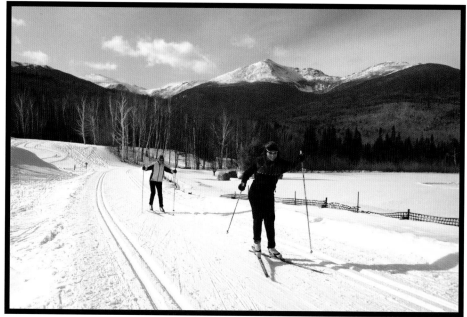

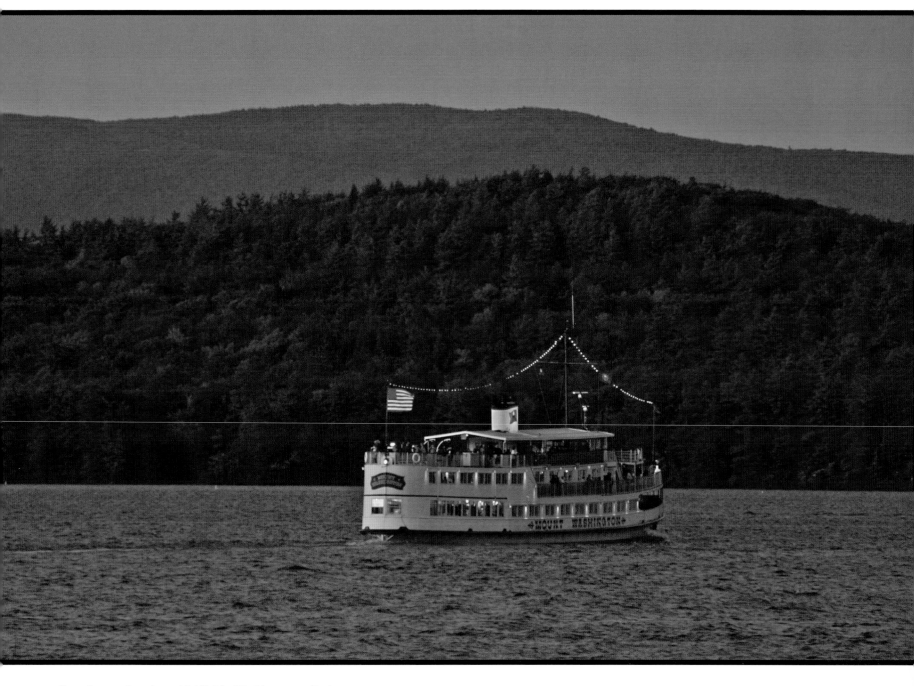

Evening cruise aboard M/S *Mt. Washington* on Lake
Winnipesaukee

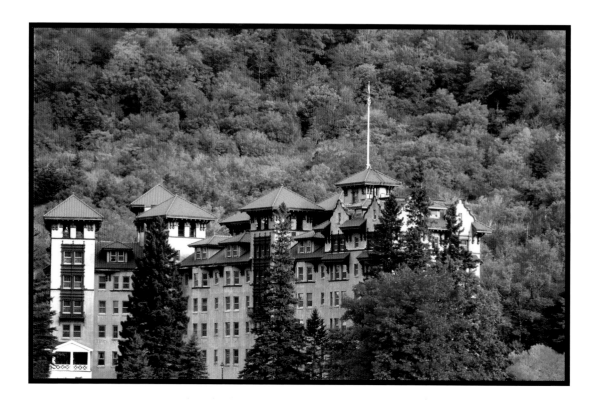

Right: The Balsams resort hotel, Dixville Knotch

Below: Climbing the Tuckerman Ravine Trail for spring skiing

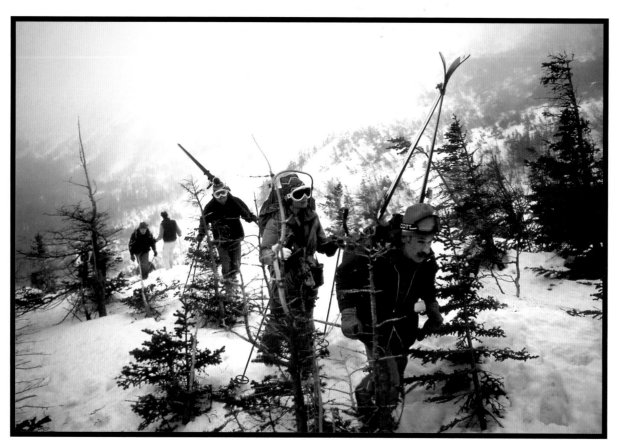

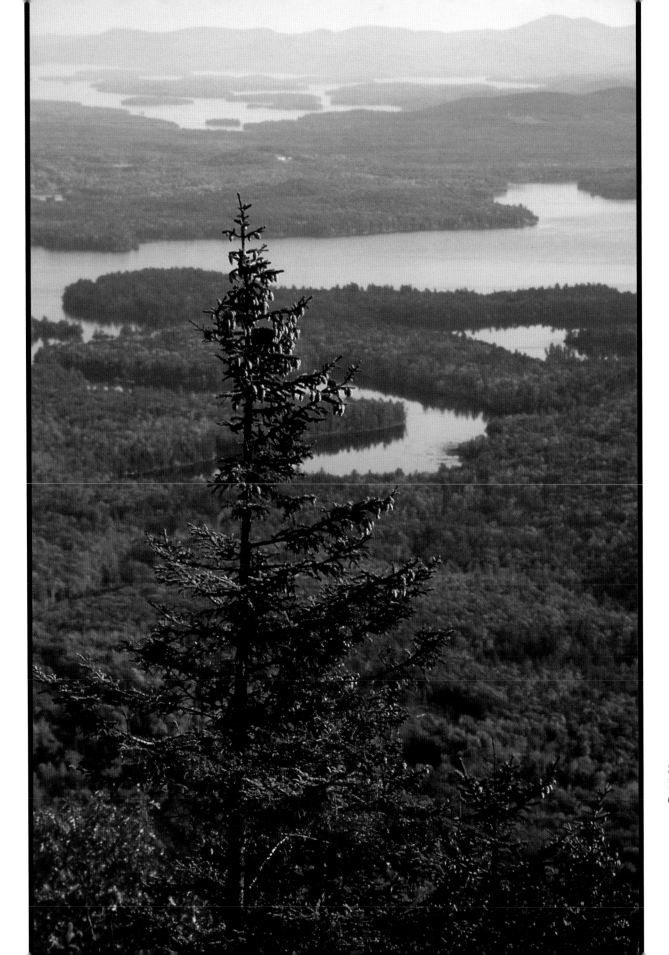

Squam Lake from
Percival Trail, Grafton
County

MAINE

I paddled the Allagash, saw first light from the peak of Cadillac Mountain, felt fog on my face on Mt. Desert, watched potatoes being harvested, climbed down the cliffs at West Quoddy Head Light, saw Baxter State Park in early snow, and met a moose wearing spring horns. I discovered dogsledding and ice fishing, puffins and lobsters. Maine is quite a state!

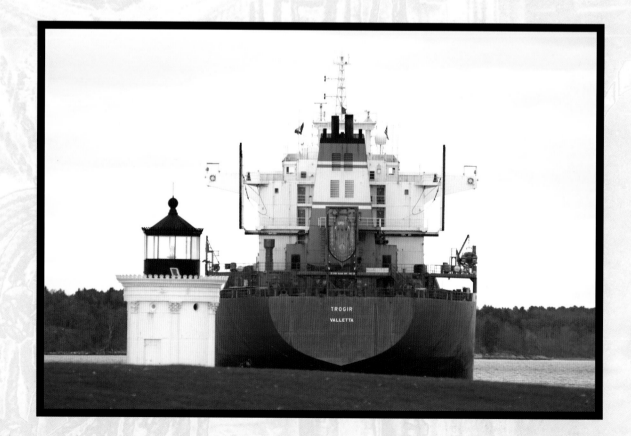

Right: Tanker beside Portland
Breakwater Light ("Bug Light"),
Portland Harbor

Far right: Bailey Island

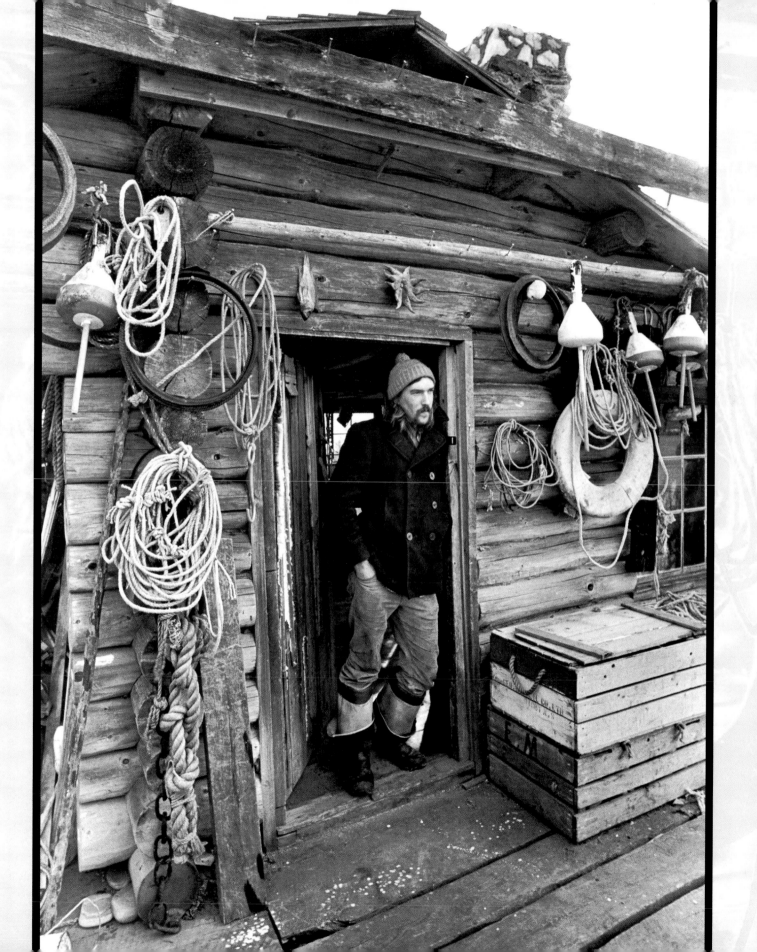

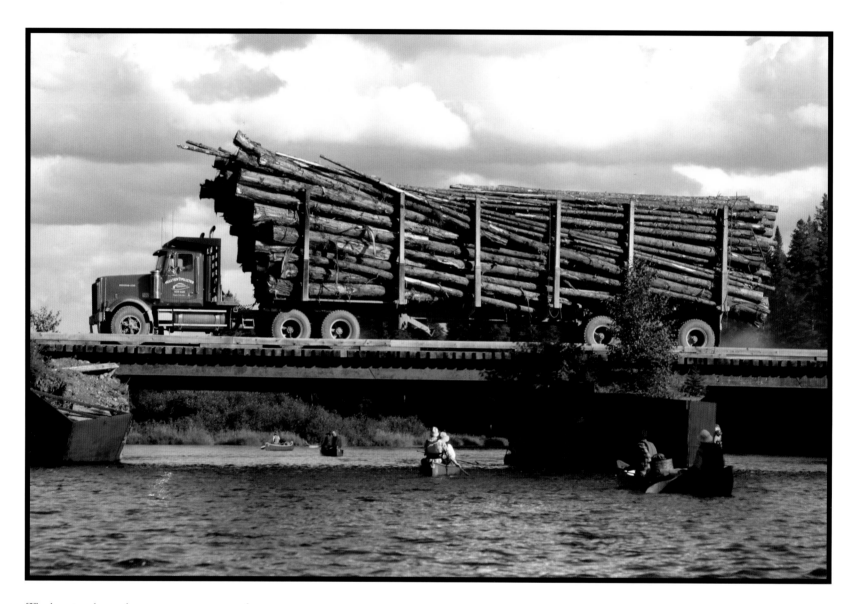

Timber trucks and canoes pass one another at a
bridge over the Allagash Wilderness Waterway

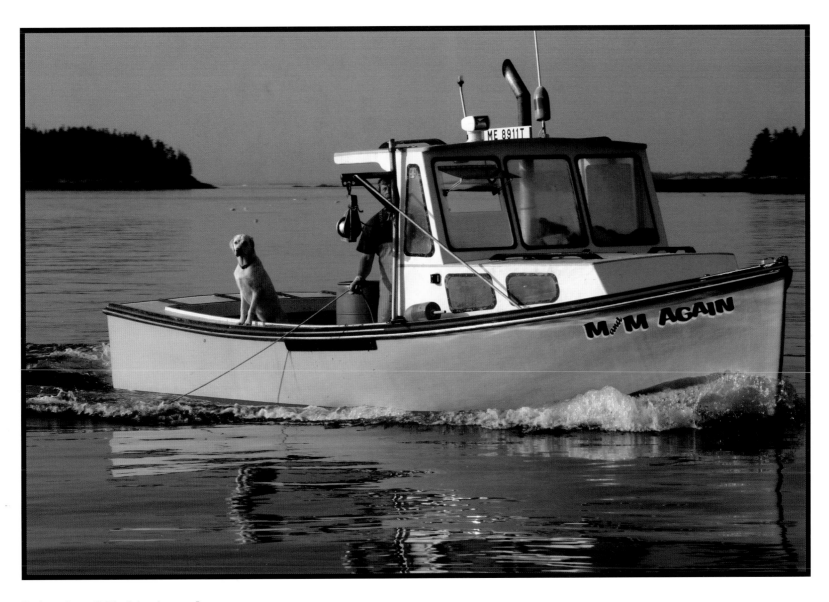

Lobstering off Pig Island, near Jonesport

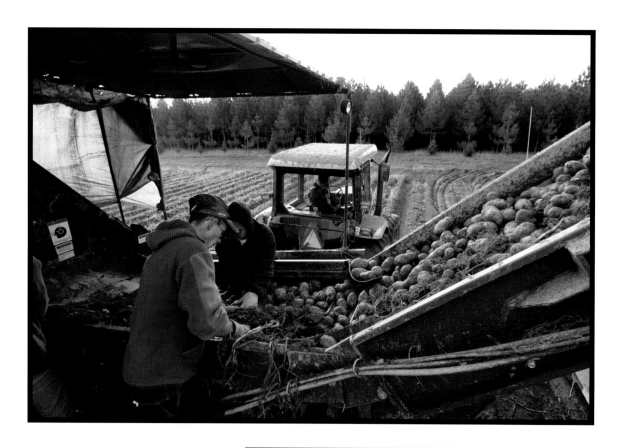

Above: Potato harvest, Aroostook County. Potatoes are freed of roots and mud as they pass on a conveyor belt.

Right: Antique wagon on farm, North Cutler

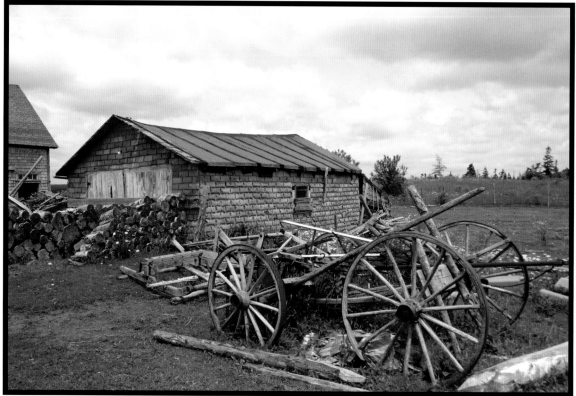

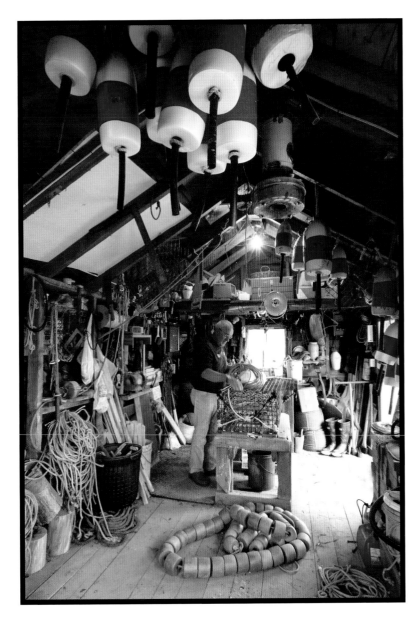

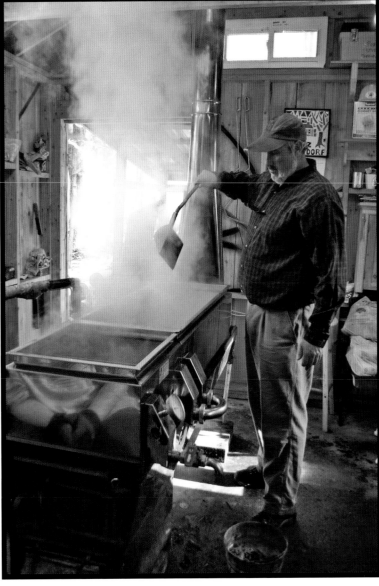

Above: Beals Island lobsterman adjusting traps in his shed
Right: Maple sugaring, Skowhegan

Left: Munjoy Hill from Portland
Breakwater Light, Portland

Below: Laundry, Great Wass Island

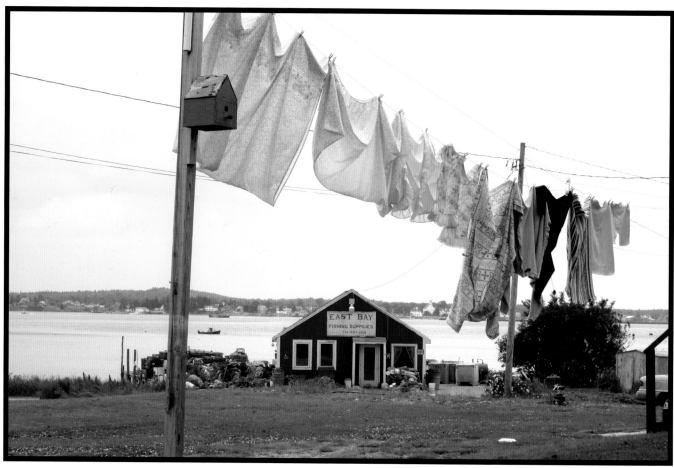

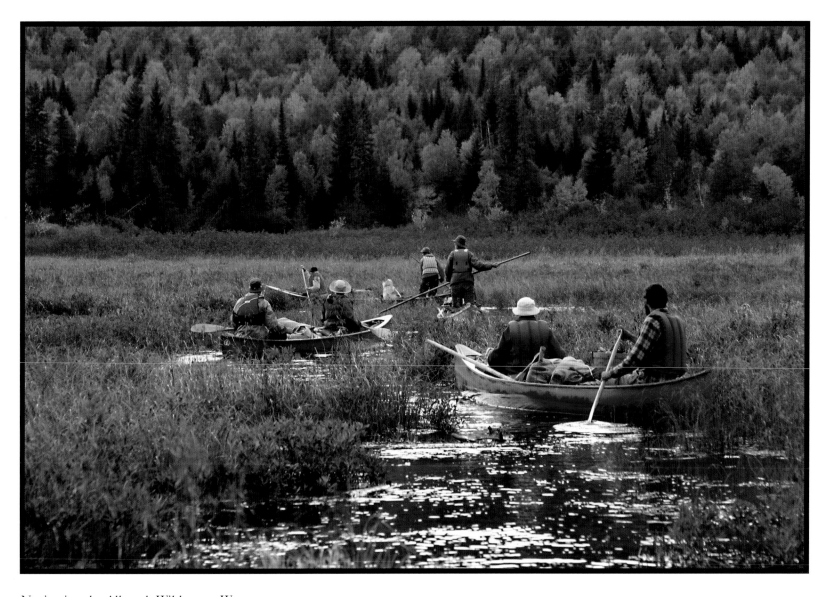

Navigating the Allagash Wilderness Waterway

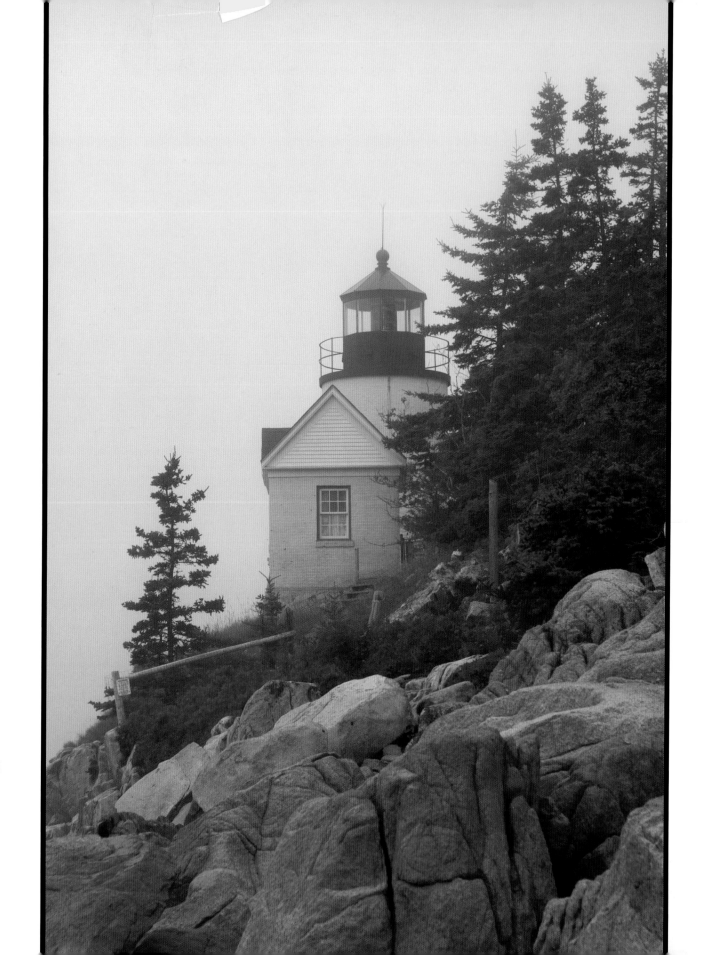

Bass Harbor Head
Light, Mt. Desert
Island

112

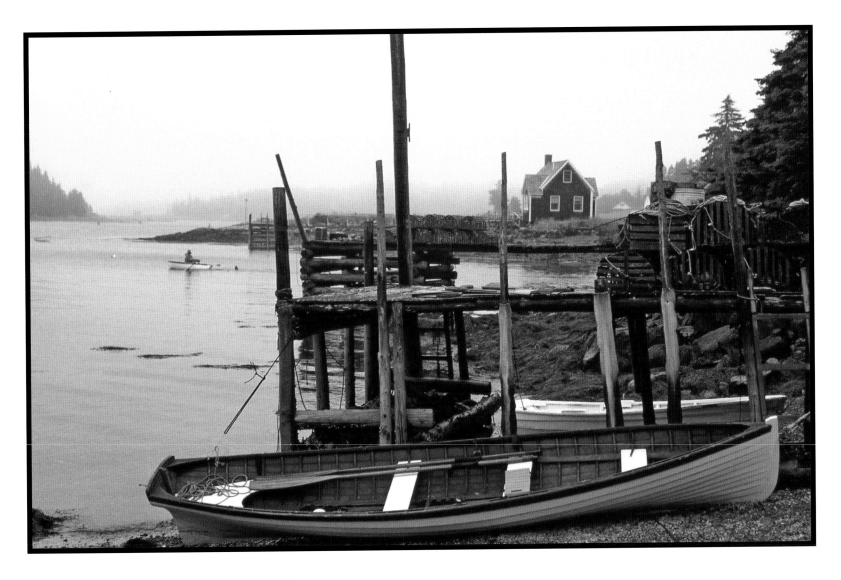

Above: Docks, Isle Au Haut
Left: Sardine canner, Prospect Harbor

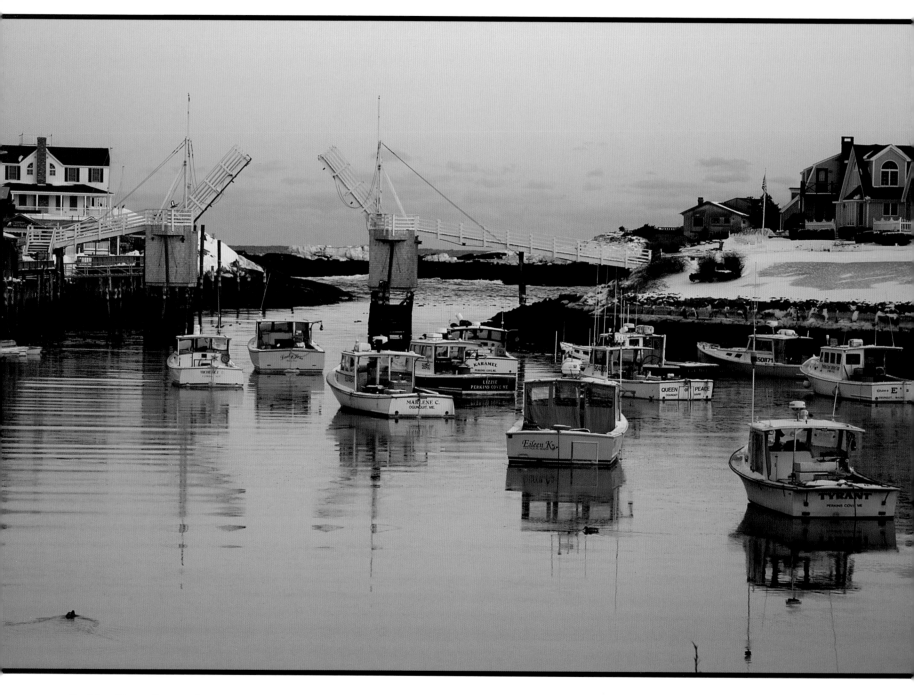

Perkins Cove, Ogunquit

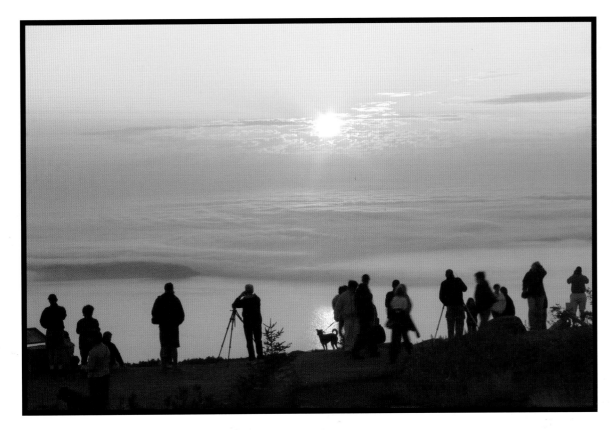

Sunrise from Cadillac Mountain, Mt. Desert Island, said to be the first place on the Atlantic coast hit by the rising sun

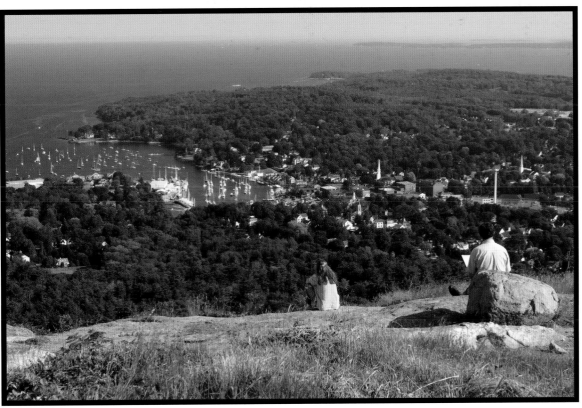

On top of Mt. Battie, Camden

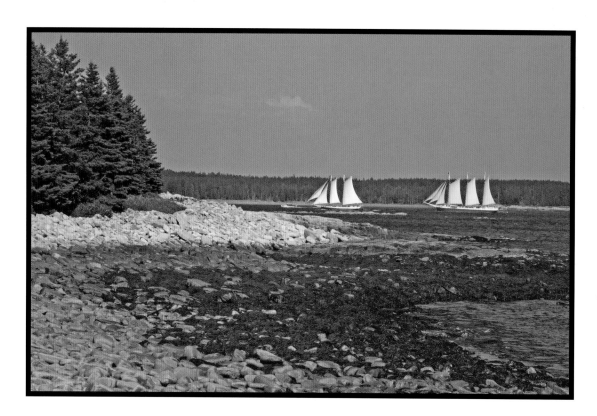

Left: Windjammers off Mt. Desert

Below: Fall colors at Rangeley Lake, Rangeley

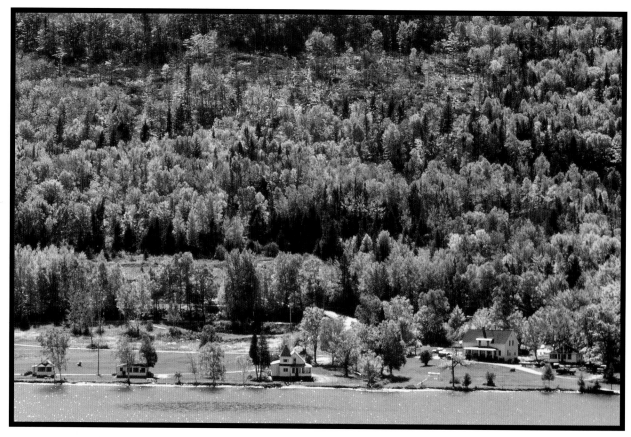

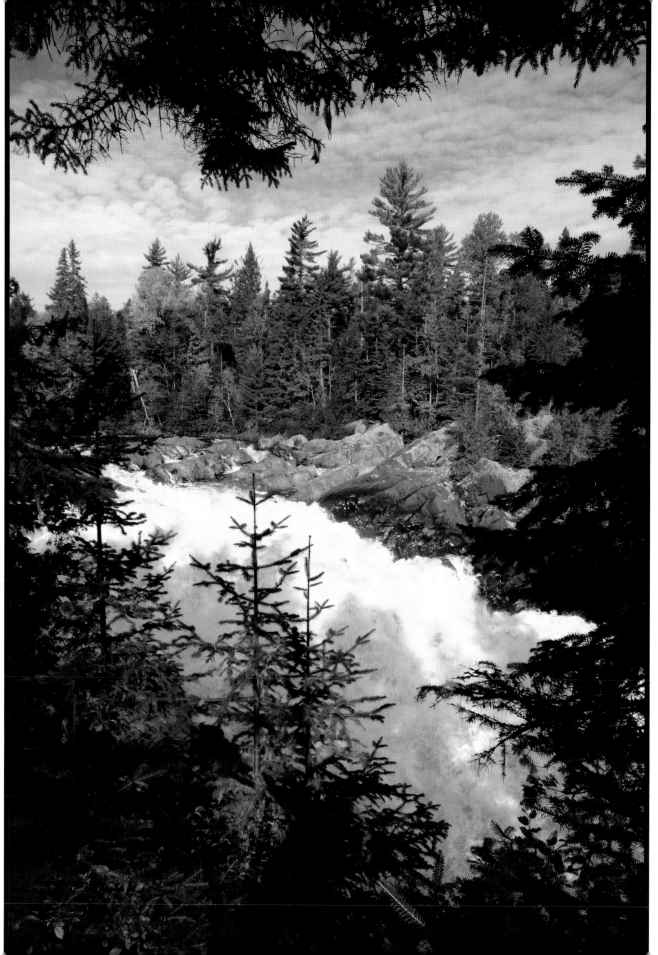

Allagash Falls,
Aroostook County

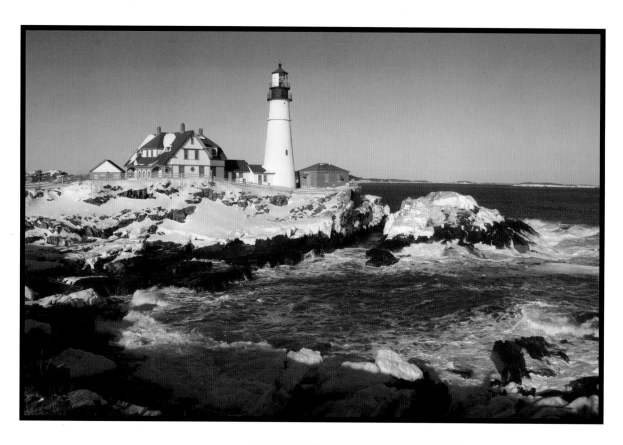

Above: Portland Head Light,
Portland

Right: Walking, Manana Island

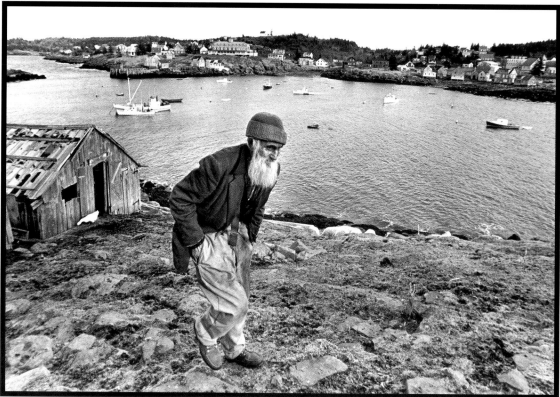

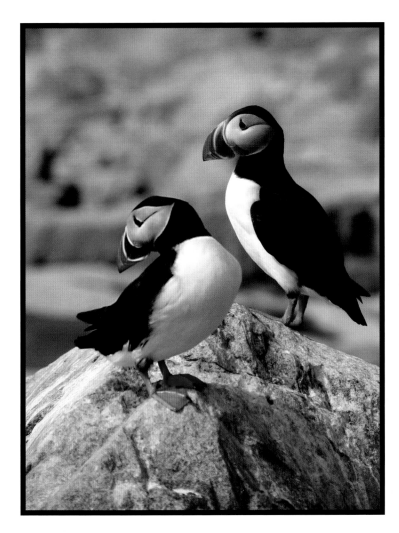

Above: Atlantic Puffins, Machias Seal Island

Right: Maine State Capitol from the entrance of Blaine House, Augusta

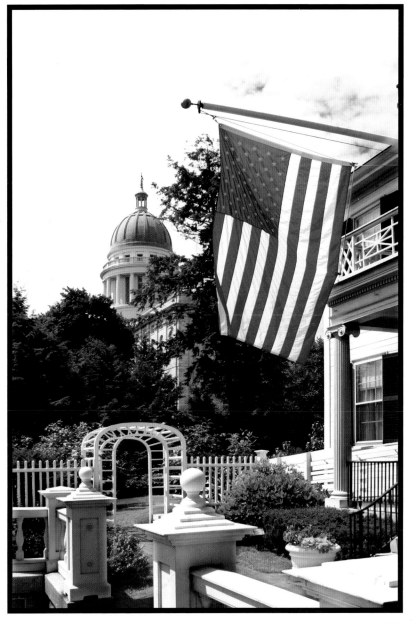

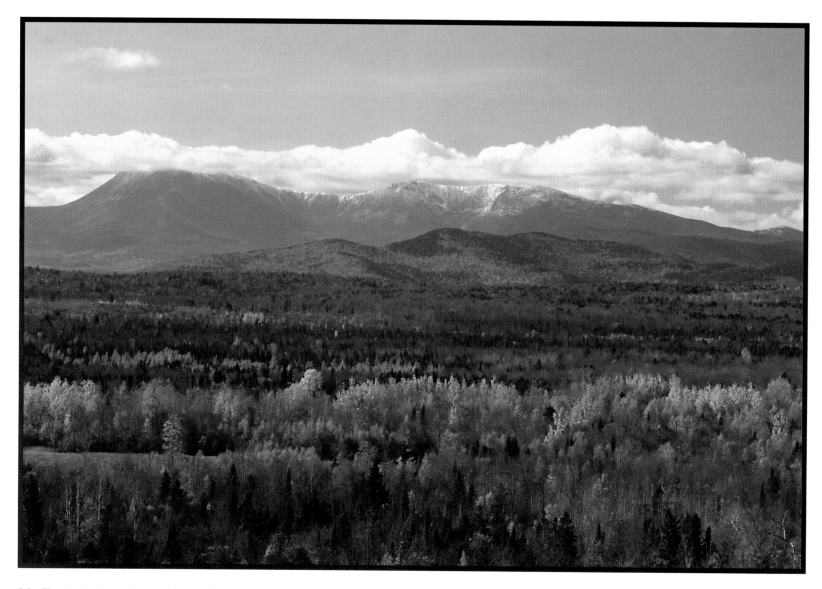

Mt. Katahdin, from Route 11 near Patten

Early morning, Caribou

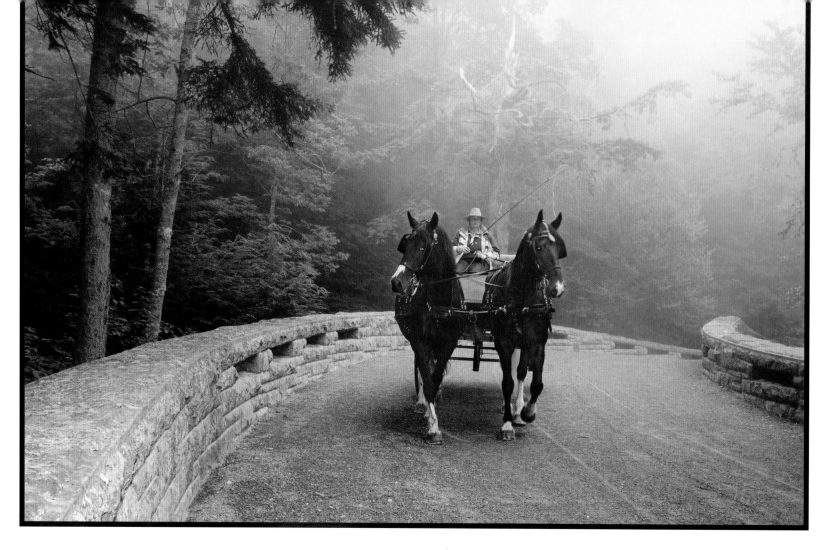

Above: Amphitheatre Bridge, Acadia National Park, Mt. Desert Island. This is the longest of the stone crossings in the network of carriage roads created by John D. Rockefeller, Jr.

Right: Guide and client set out with team of huskies for overnight trip, near Upton.

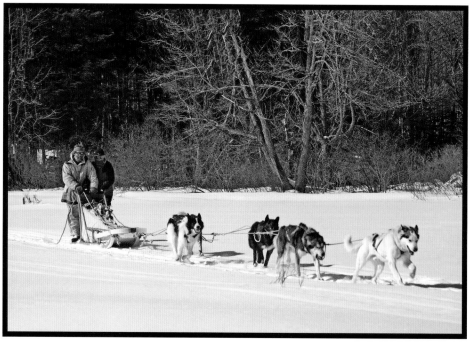

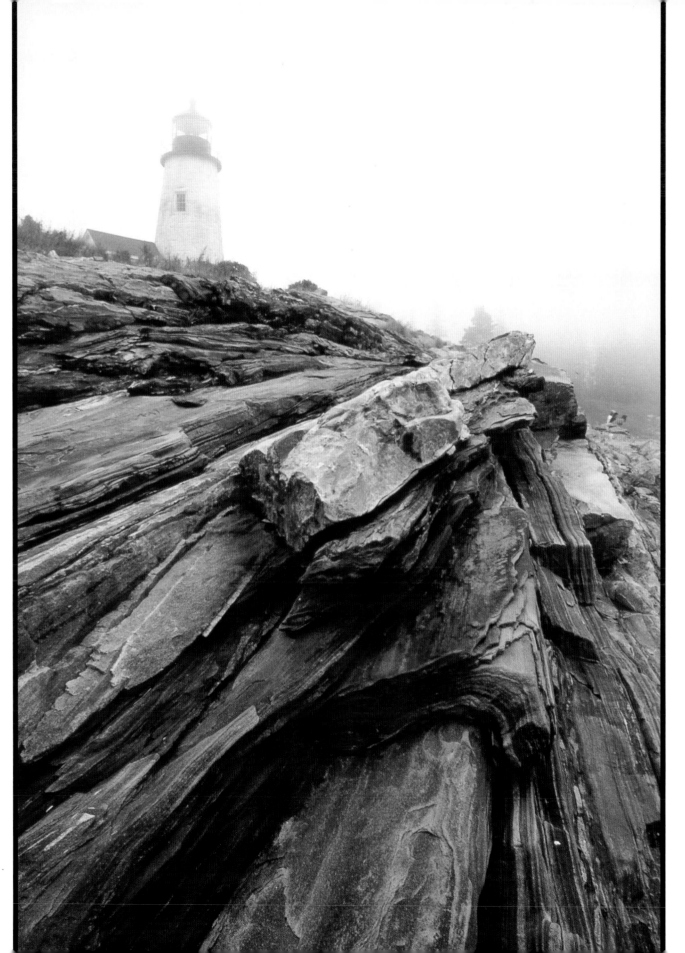

Pemaquid Point
Light, Bristol

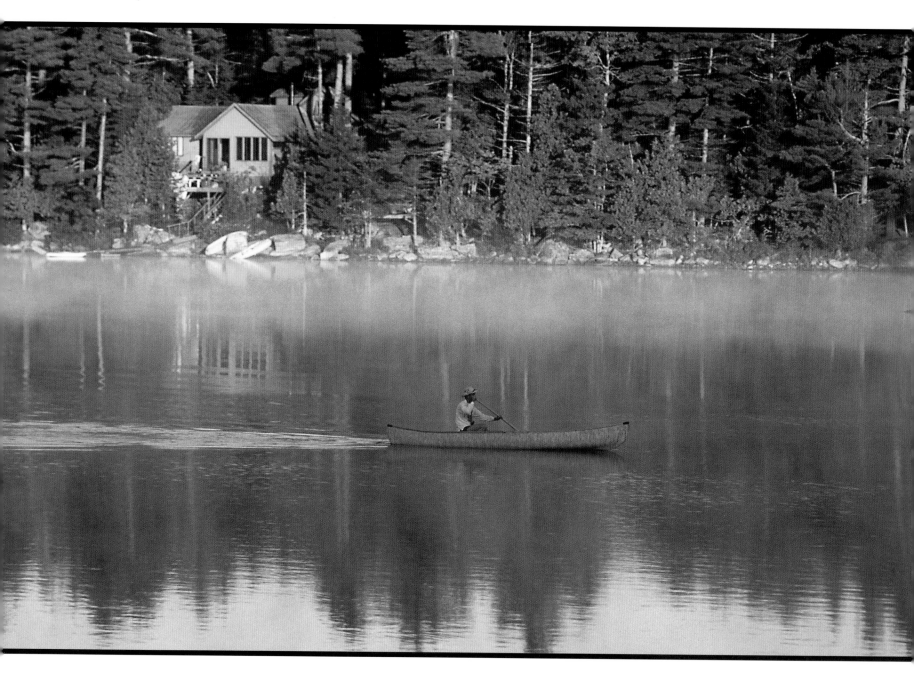

Canoeing on Somes Sound, Mt. Desert
Island, said to be the only natural fjord
on the East Coast of the United States

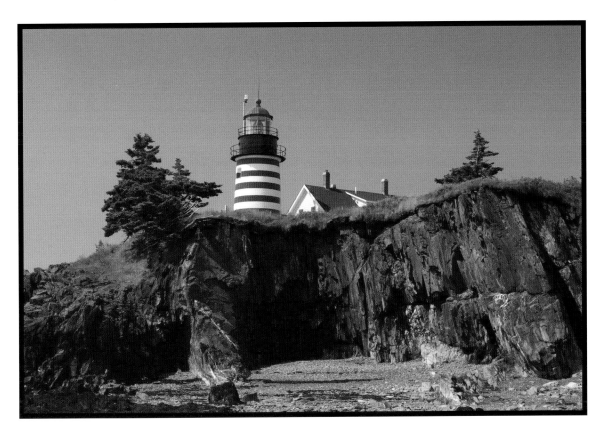

Above: West Quoddy Head
Light, Lubec

Right: The Olson House,
as seen in Andrew Wyeth's
painting *Christina's World*,
Cushing

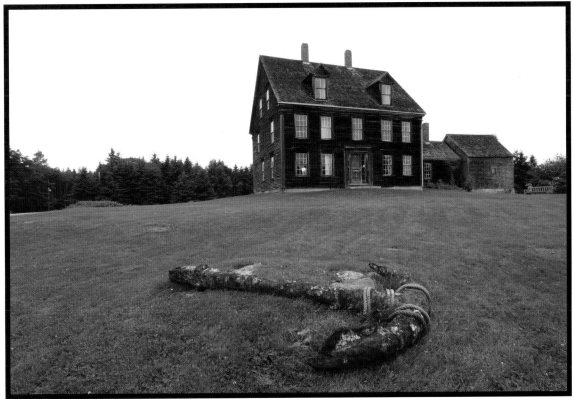

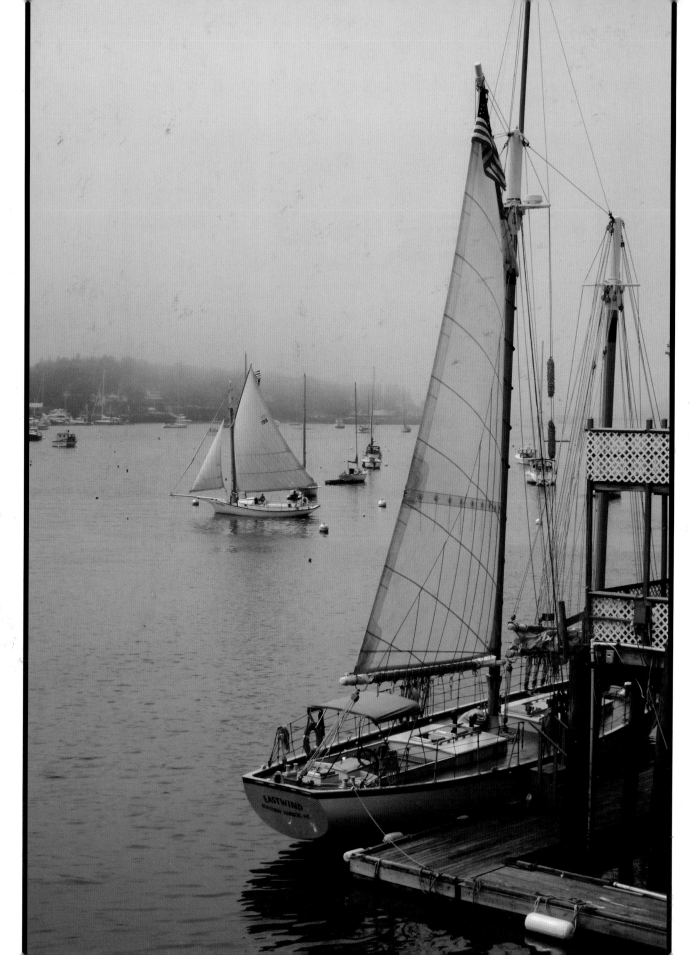

At the pier,
Boothbay Harbor

126

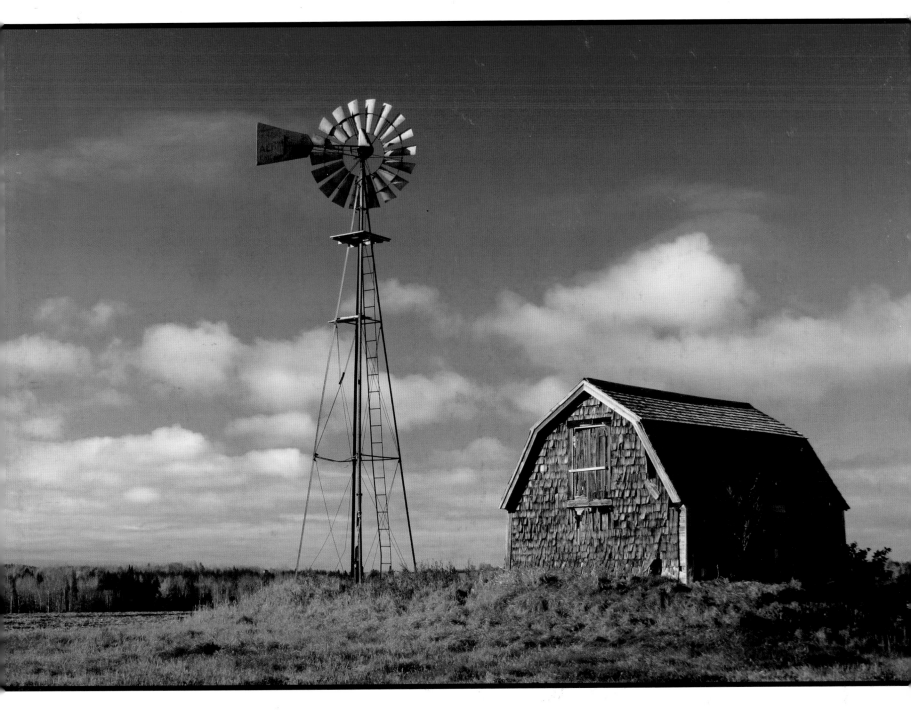

Old barn and windmill, Caribou

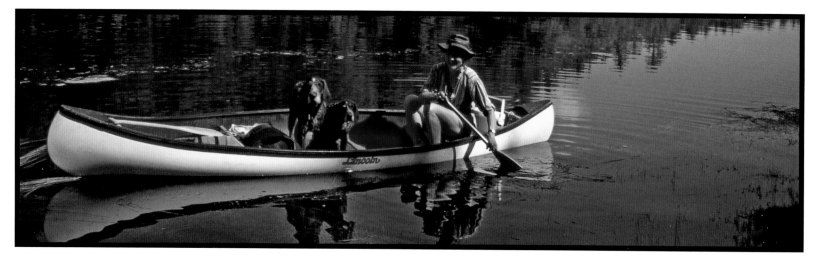

Suzanne Walther Harrell photo

ABOUT ULRIKE WELSCH

Ulrike Welsch was born in Bonn, Germany, during World War II, while her father was a brewmaster. He was also an amateur photographer, who did not live long enough to see his daughter excel in the field. In her teens, Ulrike (known as Uli) decided to become a druggist, an occupation that required knowledge of herbology, chemistry, cosmetics, health products, and photography. Uli quickly took a fancy to the darkroom, where she learned from a master printer. She began taking her own pictures with her father's Rodenstock.

After receiving her diploma, she began specializing in photography. In 1963, her mother died. To refresh her mind, Uli took a cruise to Greece and Egypt, where she met an American woman who offered to sponsor her if she decided to come to America. "I was fancy-free and quite self-reliant for my young age. I thought it might be interesting to see America for one or two years." She wrote ahead to several camera stores in Boston, because New York seemed too big for comfort.

With her Rolleicord over her shoulder, she arrived by boat in the fall of 1964. She quickly landed a job in a Boston camera store and lived with four roommates, sharing one bathroom, on Beacon Hill. During lunch breaks, on weekends, and even at night, she took pictures, roaming the parks, the zoo, the Charles River, the markets. She made her own prints with an enlarger she had brought from Germany.

Ulrike Welsch had her first one-woman exhibition in the Café Florian on Newbury Street. She sold images to the *Christian Science Monitor* and the *Boston Globe Sunday Magazine*. After one year in the camera store, though, she felt that she had

hit the wall. She spent a summer in Colorado teaching photography to children, and with her self-confidence at new heights, she approached the *Boston Herald Traveler* for a job. She was hired within a week—the first woman staff photojournalist at a Boston newspaper. She worked there for five years.

In 1972, Uli went to work for the *Boston Globe*. Editors there let her discover, and develop artistically. She also covered some of the big Boston news events of the time. In 1977 the first comprehensive collection of her work, *The World I Love to See,* celebrated some of her discoveries.

In 1978 she took a seven-month leave of absence to photograph *Rituals in the Andes,* which she says taught her that "We don't need so much." In 1981, she ventured into a freelance career. Twenty-five years later, she is still exploring the world. Ulrike Welsch has taken pictures in Australia, Thailand, Cambodia, Mongolia, Africa—the international list is far too long. But always she has come back to her home north of Boston and to New England. A meeting with Commonwealth Editions publisher Webster Bull in 1998 has led to her five most recent book projects: *Marblehead, Boston's North Shore, Boston Rediscovered, Revolutionary Sites of Greater Boston,* and now *New England Rediscovered.*

She says: "My contribution while on this earth, hopefully, has been to give people joy and happiness through my vision. I hope I have lifted their spirits. I always look for harmony and joy, for drama in design, for good composition, for a message perhaps, for a smile. It has been quite a journey which, with some adjustments, I happily would take again."